CW00797101

philosophy n art

Richard Osborne

First published by Zidane Press in 2008.
Copyright © Zidane Press
Zidane Press Ltd.
PO Box 20
London N4 2AU.

Design and layout by Anastasia Sichkarenko

The rights of the authors to be identified as authors has been asserted in accordance with Copyright, Design and Patents Act 1988. Any unauthorized broadcasting, public performance, copying or re-copying will constitute an infringement of copyright. Permission granted to reproduce for personal and educational use only. Commercial copying, hiring, lending is prohibited.

Distributed by:
Turnaround Publisher Services Ltd.
Unit 3
Olympia Trading Estate
London N2Z 6TZ
T: +44 (0)20 8829 3019

www. ZidanePress.com

British Library Cataloguing in Publication data.
A catalogue record for this book is available from the British Library.

ISBN 978095482109

philosophy

in art

Richard Osborne

Contents:

Philosophy and Art

Ever Since Plato talked about the way art could only produce a secondary, inferior copy of a higher reality philosophy has sought to contain, explain and quantify the way that art functions, and analyse what it is 'about'. Many artists have felt that this was a futile, analytic posture that was typical of philosophers and rationalists, and which could never encapsulate the 'truths' of art. In the twenty-first century the battle is still raging but it has taken a further turn, one in which philosophy and art have developed a symbiotic relationship, a closeness that no previous era could have envisaged. Trying to map these connections, and disconnections, between philosophy and art is an interesting and complicated task which writers in this volume have approached in many different ways. The idea is to provide a snapshot of where some of the debates are at and to relate them to ongoing artistic practice. The book is divided into two sections; the first part contains major essays about contemporary art questions and the second specifically relates philosophical questions to an artists' individual work. Rather than systematize the arguments the resonance and dissonance between theoretical pieces and individual statements perhaps provides an easier way into the debates.

"Artists need philosophy like a bat needs contact lenses"
Ismail Abromovich

Richard Osborne

7

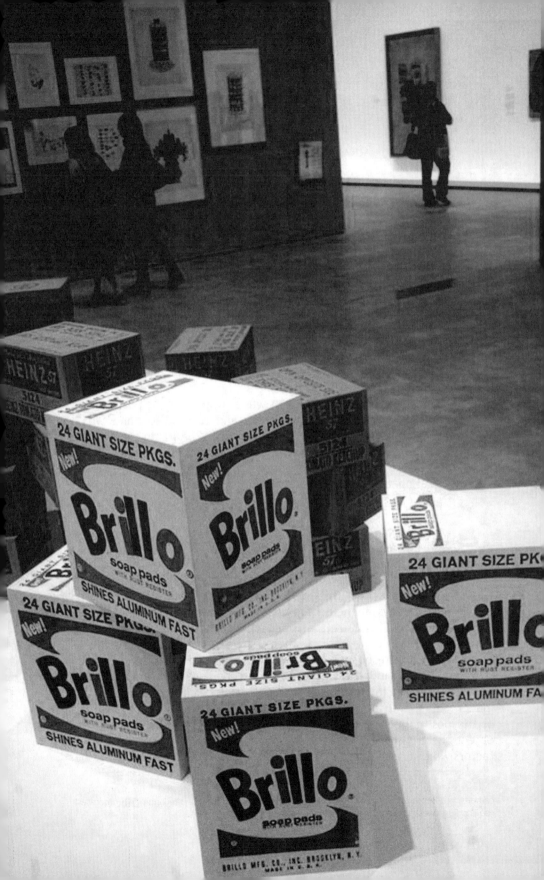

Art and the Mass Media: the mechanical work of art in the fate of reproduction.

"To an ever greater degree the work of art reproduced becomes the work of art designed for reproducibility"

Richard Osborne

There is only one place to start, historically and theoretically, with a discussion of Art and the Mass Media, and that is with Walter Benjamin and his notorious article " the work of art in the age of mechanical reproduction", sometimes interestingly re-translated as 'the work of art in the age of technical reproducibility.'[1]Translatability is also, of course, something that Benjamin was interested in, and he makes the point that the 'after-life' of a text is indeed part of its being, its 'reproducibility' from one context to another.

This 'reproducibility' is at the centre of all discussion of art and the mass media, and its latter day digital dimension is the ghost at the heart of the postmodern problematic. Alongside the reproduction of the art-object these historico-aesthetic realities which Benjamin considers are factors which are central to rethinking the work of art in the era of global

[1]Discussion about 'reproducibility' exists from the early 19th century, and centred around the camera, but Benjamin brings out the full impact of nascent cultural and technological processes. see Das Kunstwerk im Zeitalter seiner technischen Reproduzierbarkeit.

mass media. Benjamin's optimism about the democratising potential of the mass media seems now however mere nostalgia for an era where modernism seemed to be opening out cultural debate and technology liberating mass culture. The mass media was to strip not only the aura from the work of art but eventually the possibuility of the work of art itself as an embodiment of critical distance; what Benjamin saw as the liberation of the audience from the auratic spell turned out to be the substitution of a new, and more powerful, magic for an older elitism.

In a letter to Horkheimer on October 16th, 1935 Benjamin wrote "art's fateful hour has struck for us and I have captured its signature in a series of preliminary reflections"[2] Those preliminary reflections became his single best known piece of work and signals the moment when art-criticism entered a new modality. It was, in fact, in 1935 that the first television pictures were broadcast in Germany;[3] and it was that rather than the new Nazi position on art that constituted the fateful hour. Benjamin thought that the question was the politicisation of art but in fact it was the technologization of art that posed the serious questions that faced aesthetic theory, albeit futuristic questions that involve the one-dimensionality of culture, and the possibility of communication. Those questions have become dominant in the 21st century and where Art once stood above the Mass media now it swims in the electronic waters of global culture; and, some would argue, has sunk like the Titanic into popular culture.

Walter Benjamin is emblematic of a great deal about modernity and the mass media, and also of the postmodern condition; as much in his comments on art as in his dialectical understanding of the effects of the mass media. There is a deep historical perversity to his writings which have endeared him forever to the bien-pensants of academia, to whom he has become a kind of celebrity, an industry, a Nostradamus of the endless arcades of postmodern theoretical shopping. Consumerism as theoretical voyeurism is not perhaps what Benjamin intended when he started his 'arcades' project but his elevation to the status of progenitor of Baudrillardian post avant-guardism has somehow made him the media archangel of the 21st century. Benjamin possibly misunderstood everything there was to misunderstand about the twentieth century, but he did so in such an historical, and nostalgic mode, that he managed to create a theoretical universe that simultaneously embodied failure, optimism and insight in almost equal measure; this was his perverse genius. From the notion of the 'aura' of the work of art through to the cryptic notion of fascism 'aestheticizing' politics Benjamin approaches the twentieth century via the seventeenth. It is this distraction that gives his theorising about art its

[2]Long, C.P. "Art's Fateful Hour: Benjamin, Heidegger, Art and Politics "New German Critique, No. 83, Special Issue on Walter Benjamin (Spring - Summer, 2001), pp. 89-115

[3]Recent archive footage from East Germany broadcast on June 7th 2001 (Channel 4) reveals a version of daytime television that strangely prefigures today's mediascape, from cooking to conversation with stars.

strange clarity and why he could pose the right questions whilst often providing whimsically incorrect answers. Ironically it is probably only a matter of time before a Merchant Ivory film is made of his Nabakovian life story, thereby providing the final Kafkean twist to his ideas of the democritizing and distracted nature of the mass media.

The troubled question of the relationship between Art and the Mass Media is now really the central aporia of all criticism and critical practice; the art world and the mass media are locked into a dance of death in which neither wholly admits of the other's existence, but both live off each other. Andy Warhol blithely delineated this strange historical development and in so doing made the reality of the system crystal clear, that the mass media is the definer of visual culture. There is now nothing but the panoptican - art has become the means of averting the evil eye in media society - of creating a space of pretence where another visuality still reigns, or claims to - this is why art is both impossible, necessary, and iconoclastically banale in its refusal of terminal reality. The mass media is not only the message, it is the medusa of all cultural practices and artistic hope. The question then is how we can look Medusa in the eye, is art a shield that will protect us from her baleful stare? Has art, as some argue, become merely decoration for the consumer life-styles that the mass media propagate, delineate and deify as the end-point of all history, or is it the home of the suburban terrorist, the avant-guarde of the curator's last-stand and the mass practice of a new democratic populism? Or as Micheal Phillipson puts it:

> The question that the 'visual' arts throw up for and back to
> cultural analysis now is whether the concept of 'visual culture'
> is oxymoronic.[4]

However we need to retrace our steps somewhat, back to that fateful hour that Benjamin called up, in order to pose the questions raised by art theory, and to consider the impact of technology on aesthetic practices, for that is the unspoken nexus of Benjamin's concern with modes of apperception, of experience. Most importantly, of course, Benjamin insisted on the historicity of experience, on the changing socio-economic conditions that determined the production and consumption of the work of art, and on the modes of sense-perception that corresponded to certain eras of social and political change. Writing in a historical moment when new technologies of mass reproduction were altering the terrain of daily life, Benjamin probed the relationships between 'high' and 'mass' culture, between Romanticism and modernity, between film and perception. In doing so, he helped frame the central questions of what we now know as cultural studies, as well as elliptically posing the question of the plight of aesthetics in a techno-media culture,; it has to be said though that he never offered anything resembling a comprehensive theory of culture.

[3]Phillipson, M 'Managing Tradition' The plight of aesthetic practices and their analysis in a technoscientific culture. NGC.

The issues raised by Benjamin have haunted aesthetic theory, and culture, since the 1930's, and were re-visited by Mcluhan in the 1960's and formed the basis of much of postmodernism's engagement with aesthetic and artistic questions in recent times. The issues are so intertwined and so complicated that it is worth briefly trying to summarise the main arguments that Benjamin posed at that fateful hour in TWOAITAMR. (as it is known)

1) That the nature of technological advance transforms the production and consumption of works of art, and of the modes of experiencing those works of art. (This can be called the cultural/technical thesis)

2) That the means of technical reproduction transforms (destroys) the aura of the work of art, undermining its authority through reproduction and liberating the work from history.

3) That new means of technical reproduction, like photography and cinematography, can bring out aspects of the original that escape the naked eye, this exposing to the viewer the inner life of the work.

4) These new means of reproduction reduce the distance between the object and its viewer, as it can bring the copy into situations which were previously inaccessible for historical and cultural reasons.

5) These changed conditions undermine the unique existence of the original work of art and call into question its authenticity. This allows for the possibility of new forms of art.

6) This change in the status of the work of art holds democratic potential in its liberating of the historical elitism of art practices and in technological liberation of the viewer.

7) In penetrating the space of the 'aura' of the work of art Benjamin draws attention to the historical basis of this notion, to the mystique of authenticity surrounding the original work of art and to its basis in shared sociological experience.

8) The sacred, ritualistic dimension of the work of art is undermined by the processes of cultural/technological transformation and replaced with a new mode of perceiving, of exhibiting rather than of cult status.

9) That film in particular produces not the individual viewer but the collective subject who approach the work not in a spirit of adulation, but of critique and of disinterestedness. This is the "shock effect" of film.

10) That the new kind of viewer is 'distracted' by film, rather than concentrating in the traditional manner, and that distraction is positive in that it confronts the viewer with the contradictions between the work and its reception.

All of these factors represent an important crystallization of artistic, social and technological developments that had been going on for at least a century, Benjamin's genius was to illuminate them at the moment of the "big bang". This schemata represents a truncated summary of some of the positions Benjamin outlines in TWOAITAMR but brings into focus the key issue, a realisation that the technological development of society, or the technical/cultural dialectic, drives the development of aesthetic practice within modern societies. Art, in other words, whatever its Heideggerian claims to originary meaning, however distant, is in fact susceptible to the relativising forces of the transformation of the auratic nature of art. This fundamental claim is profoundly shocking and, despite Benjamin's resistance to his own theorizing, leads to the destruction of the unique-ness of the work of art, to the stripping away of the inner nature of the aura and thus opens up the field of perception to the elaborations of a new technological media, the mass media. In a new virtual reality the 'optics of the unconsious' have been opened out into the electronic void of visual apparatuses that render the unconscious visible, and the self, self-reflecting.

Whilst Benjamin's work couched all of these questions as a retrospective analysis of technology's impact on works of art, he also opened fragmentary questions towards the future, questions which posed the nascent mass media as arbiters of forthcoming social and cultural change. In de-mys-tifying the aura of the work of art Benjamin placed the spotlight of film technology firmly on the philosophical clouds of modernist organicism, and this angelic act of insouciance broke the auratic spell of meaning, the myth of identity in artistic production, and laid the grounds for the gradual dissolution of art's self assurance. The mass media are the means of the mass destruction of the authenticity of artistic practice and this downfall of the aura is indeed the grounds,as Benjamin so astutely hints, of the possibility of another kind of artistic practice: one that is still, at best, emergent. The question of the art-object in the digital world is simply one that most critics are reluctant to engage with, precisely because they have no idea what it is they should engage with.

Elsewhere Benjamin resisted the siren call of the mass media and hung on to a notion of the work of art as self-contained, as being a thing-for-itself, able to exist outside the bounds of commodity production, but this was no more than a retrospective optimism of the intellect. In "the task of the translator" Benjamin says

> In the appreciation of a work of art or an art form, consideration
> of the receiver never proves fruitful.... Art posits man's physical
> and spiritual existence, but in none of its works is it concerned
> with his response.... It tells very little to those who understand it.
> Its essential quality is not statement or the imparting of information.
> (introduction to a Baudelaire translation, 1923)

Despite Benjamin's nostalgia for the self-contained unity of the work of art he himself had pointed to the inexorable conclusion that a new technological culture that opened up all forms of perception to the gaze of the sociologist meant that hereafter the work of art would always be subjugated to the mass media's potential reconstitution of the forms of symbolic thinking and of their mobilizing of artistic perception. The confrontation of art as a critical, self-reflexive practice, and as an established discourse of aesthetic certainty, and of the popularising new media was fatefully destined to end in resistance and subjugation, in new ways of seeing, but ways of seeing that were technologised. To put this in a political vein we can quote Pierre Bourdieu in his polemical work On Television, where he says,

> *I think that television poses a serious danger for all the various areas of cultural production - for art, for literature, for science, for philosophy, and for law.*[5]

To put this at its bluntest we can say that the spaces of discourse within which art operated as a quasi-autonomous practice have been quietly and consistently colonized by the mass media and that art, like religion, has been marginalized in the secular promotion of a pleasure seeking narcissistic culture. Visuality is the means whereby the consumer becomes the object of their own self-admiration in the reproduction of a society in which viewing, of one-self and the other, is the inauthentic truth of all culture. The binary oppositions of high and popular art have actually been incorporated into an advertising culture in which high-end consumerism has been 'branded' through the importation of art into a globalized, post-identity narrative that is self-consumption. The fateful hour is one in which the aura of the work of art has been revived as a digital shadow that can be harnessed to anything, and anyone.

Philosophically speaking in the digital age we need to re-think the 'optics of the unconscious' in their postmodern guise, and in respect of the different media, practices and modes of perception. It is this task that the fact of multi-media makes Sisyphean in its constant transformation of the nature of the image; we need a mode of analysis that is always transient, and which can differentiate the philosophical points of being of self-in- the -ether. Each mode of technological transformation poses a particular problem in respect of an artistic practice and the end point is the dissolution of all art-practice into the digital, thus it is an aesthetics of the digital that must be sought in the coils of the mass media and its promotion of inauthenticity. From film, radio and television we have to move on to interactive media and the endless reproduction of all images, and of the means of reproduction themselves. From the family snap to the self in the simulacrum is the philosophical post-Benjamin journey that aesthetics requires.

[5]Bourdieu, Pierre. On Television and Journalism. Pluto Press. 1998.p.10

The decadence that began to engulf this medium of TV was thus not just due to its having yielded to the commodity but to that commodity's having been swallowed by kitsch, which is to say, the fraudulent mask of art. The artiness of the mass media that erodes both the aura of this humanity and its possessor's authority, ultimately erodes the possibility of art as well. The mass media is the unconscious of a social system in which signification is no longer possible, which is why art becomes the repressed signifying apparatus of a panoptical society. But what does this relationship mean - in terms of the perception of the world - and of the possibility of art? It means avoidance, refusal, embracing and Ottomanising- the relationship of art to power (the terms of narcisicism in a decorative world) so art goes underground - which is the glass eyed one-dimensionality of avant-guarde chic as the anti-odeipal, the non-eye of the televisual . To put this another way we can say that the violence that the system perpetrates on the viewer ultimately finds its expression in the subterranean resistance that art attempts to offer up to the world; that is why the art-object is so fractured.

We can return to the beginning with photography, and the history of the decline of the image qua image is still be written, and whether it was as the example of Roland Barthes's mythology or of Jean Baudrillard's simulacrum, by the 1960s photography had left behind its identity as a historical or an aesthetic object to become merely a theoretical object instead. From photography to film the persistence of the aura of image-object in the fixity of ideology is a reality that the critic still turns their gaze from, as though belief will suspend the magic of presence. What was in photography, the perfect instance of a multiple-without-an-original, the photograph--in its structural status as copy--marked the site of so many ontological cave-ins. The endless reproduction of the copy not only facilitated the quotation of the original but splintered the supposed unity of the original "itself" into nothing but a series of quotations. And, in the place of what was formerly an artist, the operator of these quotes, in being redefined as pasticheur, was repositioned to the other side of the copybook to join, schizophrenically, the mass of its readers. The viewer had become the author, and vice versa. This is the secret of the mass media.

Benjamin was right when he talked about the revolutionary impact of film, particularly on the audience, but even peering into the future he could not have foreseen the shrinking of the screen, till it became the personalised self-reflection of the distracted viewer. Film has redefined Western culture and the moving image is the industrialized freedom of the viewer/spectator to be part of the mediascape of consumer culture, all narrative is consumption and identity is narrative. Narrative film produced celebrity culture, which is the electronic means of the reification of individualism in latter day secularised spectatorship. The audience is distracted but that is by the simulacrum, and in this world the artist has

been recreated as Andy Warhol, who is, in effect, merely a copy of himself in endless reproduction. That is his quintessential genius, his death mask is the living face of all contemporary art. He is the electronic Michelangelo who is also Medusa, and Mcdonalds. As Baudrillad puts it when talking about Warhol and his repetition of images, he says that he presents

> -"*something like a truth of modern art: it is no longer the literality of the world, but the literality of the gestural elaboration of creation -- spots, lines, dribbles. At the same time, that which was representation -- redoubling the world in space -- becomes repetition -- an indefinable redoubling of the act in time*" [6].

After Warhol, Art and the Mass Media become not just bedfellows, but cohabitees in a loveless marriage of aesthetic convenience kept afloat by mutual dependence. In a bizarre gestural moment that elucidates these processes we have the film of Basquiat,(1996) the film of the life of the Warhol impersonator, where the replication of the reproduction as the acting out of the artist's life becomes the object of the narrative. Indeed the market for art-objects in the digital age demands a supporting cast of narrative, filmic and advertising techniques that ensure that the programme for the circulation of art satisfies a collective understanding as well as personal consumption, the viewer supports the collector in ensuring the aesthetic and cultural resonance of the art-object. It is thus that signification becomes truly postmodern in its contextual, globalized freedom; a freedom to escape from meaning into the after life of recycled digital resonance. It is here that Art and the Mass Media coalesce, in the organized repetition, the mechanical reproduction of the experience of the aesthetic in narrative mode, the story of art as endlessly repeated in culture shows. Art's ability to shock, to engage or enrage the viewer has been codified in the media's lexicon of placing art in a particular cultural space in which "strangeness" is naturalized in order to close the distance in critical thought. Performance art is now number 32 on the take-away menu of consumer experience, and weirdness is as aesthetically comforting as a cooking programme, even the ephemeral is endlessly repeated so that the disappearing art-object can be re-cycled to an avaricious audience. Reproduction produces redundancy which is the key characteristic of all contemporary culture.

If we take Mcluhan's theories on the nature of the mass media, which have some relevance, and look also at the way in which Baudrillard has developed those ideas it will become clear that there is some contemporary discussion of the nature of the relationship between the arts and the mass media, but that in general it is a an area that is widely ignored. John Walker's book *Art in the Age of the Mass media*[7] is almost the only work that directly confronts the question and this work is already twenty years

[6] For a Critique of the Political Economy of the Sign, p. 106
[7] Walker, J.A. Art in the Age of the Mass Media, Pluto Press, London, 1984.

old, and thereby missed out on the birth of the internet and of our digital culture which is a product of the last decade. The mass media are the aporia at the heart of the arts debate, the collectivist monster that lurks at the end of the individualistic tram-line, the terminus and the terminator of Romantic genius, except as narrative reproduction. If Cubism exploded the art-object into abstraction then the mass media reduced them to digitalized objects in which the traces of emotion and aesthetics were merely points in the transmission of electronic structure, a culture in which connectivity is the dynamic focus rather than individuality. The contradiction at the heart of the mass media is that in every movement of its globalized construction of collective being and consciousness, it reifies individuality in the elevation of the unconscious as a mechanism of narcissism. The art-object is similarly reified and obliterated in the endless flicker of meaning that passes in and through the viewer's consciousness. The art-object/image at best aspires to the status of a still frame of the digital apparatus.

In the most extreme version of his nihilistic approach Baudrillard was quoted in a paper called " Contemporary art is useless"[8] in which he argued that indeed the simulacrum was the message, and that art was no more than the end of depth, perspective, meaning, connection, or artistic freedom, saying that the "the problematization of contemporary art can only come from a reactionary, irrational, or even fascist mode of thinking." Having become a practising artist Baudrillard seems, as ever, to want to de-legitimise even his own position but in part the argument is to do with the space of meaning in contemporary culture, the whirl of synthesizing signification that electronic culture can produce automatically, artificially and constantly and which absorbs all criticality and otherness through the endless process of replication and reinforcement. Baudrillard dates these processes from the 1960's and considers Pop Art as an example of the beginning of the Warholian universe, in which art is flattened out into one-dimensional black holes. He says "Whereas all art up to Pop was based on a vision of the world 'in depth', Pop on the contrary claims to be homogeneous with their industrial and serial production and so with the artificial, fabricated character of the whole environment, homogeneous with this immanent order of signs: homogeneous with their industrial and serial production and so with the artificial, fabricated character of the whole environment, homogeneous with the all-over saturation and at the same time with the culturalized abstraction of this new order of things"

Art has been absorbed by the system of signs which is the mass media, but Baudrillard ignores the internal dynamic of a system in which technology reconstitutes signs as dynamic objects, as post-signification as we could say. Baudrillard is always caught in the endless complexity of

By Corinna Ghaznavi and Felix Stalder Note: This little polemic was written for LOLA, a Toronto-based independent art magazine.

a seamless system of signs out of which there is no escape, no external referent, this is ultimately a philosophical tautology that haunts his work and which he is oddly alluding to in the all contemporary art is useless polemic. In assigning always priority to symbolic relations, and originating his theory in the nature of a dynamic technology, he freezes the abstraction within the simulacrum and builds a network of signification which hides the technological in the reification of non-meaning.

Like every agent-provocateur however Baudrillard wants to reveal his true identity, and in calling attention to the impossibility of art he shows us that the theorist always fears both the unpredictability of reality, and the fact that theoretical systems, like technological systems, always contain the seeds of their own irrationality, the point at which art is still possible. As Ghaznavi and Stalder put it in relation to Baudrillard's claims of the impossibility of art,

> *"But discourse has a nasty tendency to develop its own dynamics*
> *and spiral around its own arguments, to become separated from*
> *the reality of production or creation which it claims as its subject.*
> *Instead of worrying about the defection of a great cultural theorist*
> *we should dispense with him quietly and wave goodbye to granddad.*
> *There is life behind the TV screen, and to understand this life,*
> *today, art is still one of the best ways to go.*[9]

In part Baudrillard's technological pessimism is almost antiquated, a pre-multi-platform paradigm when media was centrally controlled, and oddly unaware of the strange subversiveness of the internet and it's myriad ways of re-inventing reality, of refusing coherence and it is this that undermines his position. Post-signification is when reality bends around the strangeness of definition that internet interpolation allows; the real becomes so distorted it escapes from itself to become virtually impossible; that is its secret.

However there is still nothing but the panoptican – and art is the means of averting the evil eye in media society - of creating a space of pretence where another visuality still reigns - this is why art has to embrace the digital, and the impossibility of permanent meanings, and the termination of the idea of the artist as the originator of meaning. Art in some historical sense could always occupy a space in which the visual was a semi-autonomous region; the mass media has reduced the visual to an adjunct of the other senses, surrounded by consumerism and packaged as the narrative of advertising; however the insanity of such re-cycling is the moment of opportunity for the digital artist and the escapees, the artists in recidivism, who can harness the entire Universe to their peculiar ends. Art always despises itself, that is why it must theoretically and practically embrace the mass media and swoon to the opium of unlimited reproducibility.

[9]Ibid. Ghaznavi and Stalder

Bibliography.

Adorno. T.(2006) *Minima Moralia: Reflections on a Damaged Life*. London. Verso

Barasch, M.(1985) *Theories of Art From Plato to Winckelmann*. New York University Press.

Baudrillard, Jean (1968) *Le system des objects*. Paris: Denoel- Gonthier.

(1970) *La societe de consummation*. Paris:Gallimard.

(1975) The Mirror of Production. St. Louis: Telos Press.

(1981) *For a Critique of the Political Economy of the Sign*. St. Louis: Telos Press.

(1983a) *Simulations*. New York: Semiotext(e).

(1983b) *In the Shadow of the Silent Majorities*. New York:Semiotext(e).

(1983c) *"The Ecstacy of Communication," in The Anti-Aesthetic*, ed. Hal Foster. Washington: Bay Press.

(1986) *Forgetting Foucault*. New York: Semiotext(e).

(1988) *America*. London: Verso

(1993) *Symbolic Exchange and Death*. London: Sage.

(1994a) *The Transparency of Evil*. London: Verso.

(1994b) *Simulacra and Simulation*. Ann Arbor: The University of Michigan Press.

(2005) *The Conspiracy of Art*. Semiotext(e),

Benjamin, W. (1999) *Illuminations*. Pimlico; New Ed edition. London.

Bernstein, J.M.(1992) *The Fate of Art: Aesthetic Alienation from Kant to Derrida and Adorno*. Pennsylvania State University Press.

Freeland, C. (2002) *But is it art?* Oxford University Press, UK.

Kellner, Douglas (1989). *Jean Baudrillard: From Marxism to Postmodernism and Beyond*. Cambridge and Palo Alto: Polity Press and Stanford University Press.

(1994), editor Jean Baudrillard. *A Critical Reader*. Oxford: Basil Black-well.

Kittler, F. (1999) *Gramaphone, Film, Typewriter*. Stanford University Press.

Lyotard, Jean-Francois (1984) *The Postmodern Condition: A Report on Knowledge*. Manchester: Manchester University Press.

Osborne, Harold.(1968) *Aesthetics and art theory: An historical introduction* Longmans (1968)

Shiner, L (2003) *The Invention of Art: A Cultural History*. University Of Chicago Press.

Taylor, M. C., and E. Saarinen. 1994a. *Imagologies: Media Philosophy*. London: Routledge

Norris, Christopher (1979) *Deconstruction: Theory and Practice*. New York: Routledge.

Walker, J.A.(1994) *Art and The Mass Media*. London, Pluto Press.

Wollheim, R. *Art and its Objects*. Cambridge University Press; 2nd edition1992.

Ephemeral Art: A Philosophical Proposition about the Nature of Time

Zoë Tillotson

In understanding the nature of the art-object, that totemic presence of modernist art, philosophy has continually proposed the existence of the other, the non-object and it is here that the debate about the Ephemeral has become pivotal. Ephemeral art - art which is *intentionally* impermanent, temporary and transient - is hardly a new concept. The tradition of Native American Indian sand painting and the rice and pigment Rangoli patterns associated with Sikh and Hindu religious practices for instance, evidence an established and culturally diverse history. However, within the mainly Western art trajectory; the context in question, the term *ephemeral* has been applied loosely to identify a general trend pervading cultural production throughout the latter half of the twentieth century and the beginning of the twenty-first, and is therefore a relatively recent phenomenon.

This period has witnessed the birth of an enormous variety of co-existing groups, movements and activities of diverse complexion, all of which could legitimately lay claim to the term "ephemeral". For example, as

early as 1949, Christian Dotremont had presented a handful of shrivelled and decomposing potatoes in the Brussels CoBrA exhibition; *The Object Through the Ages*. During the late 1950s and early 1960s manifestos and statements issued by Gutai, Situationist International and Fluxus clearly align themselves with the ephemeral, and by the mid-1960s a plethora of impermanent artworks and practices had been unleashed. These included: Environments and Happenings which adopted 'perishable materials such as newspaper, string, food, toilet paper and adhesive tape' (Reiss, 1999 p.21); performance art, described as 'ephemeral, time-based, and proc-ess-orientated' (Brentano, 1994 p.32); and latterly, installation art 'not based on physical permanence . . . but rather on the recognition of its unfixed *impermanence*, to be experienced as an unrepeatable and fleet-ing situation' (Kwon, 2000 p.34). Such statements might equally serve to describe elements of Viennese Actionism, Conceptual Art, Land/Earth Art, Kineticism and Arte Povera.

Conflicting versions of ephemerality distinguish the above statements, residing alternately in materiality, process, performance events and ephemera. This is notwithstanding the rise of new technologies which explore the concept of impermanence in terms of virtual reality, or purely time-based mediums that continue to expand the territory in radically new dimensions. Were this essay to take as its rationale the problem of definition, these complexities would need to be unravelled. However, I begin from the premise that ephemeral art, rather than being viewed as a discrete movement, genre or style is best envisaged as a strategy, or range of strategies, closely allied with an ongoing critique of the art object and art institutional system itself[1]. In particular, I suggest that ephemeral art may be understood as a philosophical proposition concerning the nature of time. Despite an ongoing fascination with the notion of ephemerality in the last sixty years, scant critical attention has been directed at examin-ing the precise nature of time and the concept of impermanence which inform perceptions of ephemeral art. My intention here is to address that gap.

When Time Becomes Attitude: Art and Temporality in the 1960s

It seems reasonable to presuppose that any artistic practice which flirts with impermanence inevitably offers a philosophical statement about the nature of time. In order to gain insight into how and why ephemeral art has tended to conceptualise time in quite the way it does, it is necessary to examine the prevailing cultural context. Conceivably, the move towards ephemerality during the mid twentieth-century may be characterised as one of many 'seemingly opposed responses to a common situation: the

[1]Throughout this essay I use the terms "art institution", "museum" and "gallery" inter-changeably to signify a shared ideological stance insofar as time is percieved to be a threat to the durability of art objects and artefacts.

crisis of modernism' (Osborne, 2002 p.18), and thus, like Conceptual Art, continued the Minimalist project, flourishing 'in opposition to formalism' (Godfrey, 1998 p.219). Consequently, the particular philosophical proposition advanced by many of the emergent ephemeral practices needs to be understood essentially as a "reactive" one.

I begin with a re-examination of Michael Fried's seminal text, Art and Objecthood, originally published in *Artforum*, 1967, not least because Fried has come to epitomise a particular expression of modernism and therefore represents a wider ideological position. Furthermore, the article's specific relevance lies in the author's conscious articulation of two apparently distinct modes of temporality: "presentness" – a quality pertaining to the modernist work Fried admires and which on the face of it ephemeral art might be said to refute, and "presence" – an attribute of the "literalist" work he disdains. Arguably, it is the later understanding of time which comes to dominate and define *impermanence*, and *ipso facto*, ephemeral art.

Fried's Two Temporalities

In Art and Objecthood Fried outlines two seemingly irreconcilable perceptions of time which he ascribes to two different kinds of aesthetic production; modernist art on the one hand and Minimalist ('literalist') art on the other. Fried frames his understanding of time through the concept of *duration*. His central proposition is that modernist art is authentic because it is inscribed with a *durationless* temporality, whereas Minimalism, defined in contrast through *durational* time, is inauthentic. The authenticity of great modernist art, Fried purports, is dependent on its ability to absorb and incorporate the viewer completely, exemplified by the way in which someone encountering a Caro sculpture is 'eclipsed by the sculpture itself', an experience facilitated by the suspension of what might be termed "real", "everyday" or "commonsense" temporality: 'One's experience', of modernist painting and sculpture, he continues, 'has no duration . . . because *at every moment the work itself is wholly manifest'* (Fried, 1967 p.22). In fact, it would be more accurate to characterise this durationless phenomenon as *a* temporal, for it appears to transcend time altogether. Fried writes:

> It is this continuous and entire presentness, amounting, as it
> were, to the perpetual creation of itself, that one experiences as
> a kind of instantaneousness, as though if only one were infinitely
> more acute, a singly infinitely brief instant would be long enough
> to see everything, to experience the work in all its depth and
> fullness, to be forever convinced by it (1967 p.22).

Implicit in Fried's mystical style and choice of vocabulary is the claim that the contemplation of modernist art facilitates access to some divine, other-worldly state. The sense of an all-pervasive 'continuous and

entire *presentness*' is redolent of an encounter with an infinite, absolute entity beyond time and space; and in being 'forever convinced by it', the beholder acquires faith and receives salvation. As such, durationless temporality discloses a notion of eternalism for it permits 'the condition . . . of existing in, indeed of secreting or constituting, a continuous and perpetual *present*'; a timeless, transcendental realm (Fried, 1967 p.22). By contrast, Fried's argument with the kind of Minimalist sculpture exemplified by the work of Robert Morris and Donald Judd, is that it lacks this transcendent dimension, being grounded instead in durational time. Durational temporality is particularly abhorrent to Fried because it blatantly manifests and celebrates conditions in which 'the spectator perceives an object as that which it literally is, something existing in space and time' (Harrison & Wood, 1993 p.191). He writes:

> *Literalist sensibility is theatrical because to begin with it is*
> *concerned with the actual circumstances in which the beholder*
> *encounters literalist work . . . the experience of literalist art is*
> *of an object* in a situation – one which, virtually by definition,
> includes the beholder *(Fried, 1967 p.15).*

For Fried, the introduction of a spacio-temporal element demarcated by 'the presentiment of endlessness . . . essentially a presentiment of endless, or indefinite, *duration*', such that 'the experience of the work necessarily exists in time' thoroughly degrades the whole art experience (1967 p.22). Where 'presentness' bestowed through 'grace' constitutes a redemptive temporality; the end of time, its counterpart, 'presence', more resembles a spell in purgatory; continuous time without end. Citing Tony Smith's account of a drive on the New Jersey Turnpike, Fried describes the experience of things passing in time, or of time passing by *things*, hurtling headlong into the future: 'the constant onrush of the road, the simultaneous recession of new reaches of dark pavement illuminated by the onrushing headlights', as essentially 'theatrical':

> *The literalist preoccupation with time – more precisely, with the*
> duration of the experience – is, I suggest, paradigmatically
> *theatrical: as though theatre confronts the beholder, and thereby*
> *isolates him, with the endlessness not just of objecthood but*
> *of time; or as though the sense which, at bottom, theatre*
> *addresses is a sense of temporality, of time both passing and*
> *to come,* simultaneously approaching and receding, *as if*
> apprehended in an infinite perspective *(1967 p.22).*

Above all, Fried mourns the tragic 'loss of the sense of self which he associates with absorption in the enduring "present" of the work of art' (Harrison & Wood, 1993 p.191). From his perspective the literalist project ultimately fails for it constructs a 'situation' located in what Foster terms 'mundane time' (1986 p.173). As such, the spectator is condemned to a temporality which 'makes him a subject . . . and establishes the experience itself as something like that of an object, or rather, of objecthood'

(Fried, 1967 p.20). It is, in short, an experience of alienation (Brockelman, 1993).

Fried's thesis is not a denial of everyday temporality *per se*, but an attack on the idea that art should endeavour to participate in such a debased mode of temporality. This is evidenced in the article's final paragraph where Fried notes 'the utter pervasiveness – the virtual universality – of the sensibility or mode of being which I have characterised as corrupted or perverted by theatre. We are all literalists most or all of our lives. Presentness is grace' (1967 p.23). In other words, although subject, on a day to day level, to a notion of durational temporality, of things happening 'in' time, *true* (modernist) art offers a reprieve; lifting the subject out of and beyond conventional experience of time, into a time*less* realm, even if only momentarily.

More insidious still, from Fried's perspective, is the democratic impulse implicit in durational temporality. Antithetical to the formalist aesthetic he champions, which addresses itself to a sensitised elite, it challenges his belief that:

> *Certain modes of seriousness are closed to the beholder by the work itself, i.e., those established by the finest painting and sculpture of the recent past. But, of course, those are hardly modes of seriousness in which most people feel at home, or even which they find tolerable (1967 p.16).*

Not only has Minimalism 'in insisting on placing the artwork "in time" with the spectator . . . betrayed art to the realm of theatre – where the player can pretend to exist in the same temporal dimension as his audience', but worse, it is a temporal dimension accessible to all (Brockelman, 1993 p.52).

Rejecting Atemporality, Embracing Durational Time

Over the intervening years since the publication of Art and Objecthood, Fried's affectation with the notion of durationless time has been repeatedly challenged. Reasons for this have included a growing interest in the *process* of artistic production; an awareness that artistic practice does not occur in an atemporal vacuum, coupled with concerns about the commodification of art. Smithson makes this connection in his essay A Sedimentation of the Mind: Earth Projects, published in *Artforum*:

> *For too long the artist has been estranged from his own "time". Critics, by focusing on the "art object", deprive the artist of any existence in the world of mind and matter. The mental process of the artist which takes place in time is disowned, so that a commodity value can be maintained by a system independent of the artist. Art, in this sense, is considered "timeless" or a product of "no time at all"; this becomes a convenient way to exploit the artist out of his rightful claim to his temporal processes (1968 p.50).*

Secondly, Fried's concept of atemporality provoked a critique which went beyond the art object and the circumstances of its creation to the institution itself, raising questions about the role of the museum and its associated ideology of permanence. Famously, Daniel Buren's article; Function of the Museum, extended the assault on the 'illusion of eternity or timelessness' writing:

> The museum was designed to assume this task [perpetuating
> the illusion] and by appropriate artificial means to preserve the
> work, as much as possible, from the effects of time – work which
> would otherwise perish far more rapidly. It was/is a way –
> another – of obviating the temporality/fragility of a work of
> art by artificially keeping it 'alive', thereby granting it the
> appearance of immortality which serves remarkably well the
> discourse which the prevalent bourgeois ideology attaches to it
> (1973 p.38).

Thirdly, as intimated in Buren's statement above, the elitist sentiments expressed in Art and Objecthood were subject to widespread condemnation. Rejecting the reification of both the processes of artistic production and the art object itself, more inclusive, democratic models of artistic practice and criticism were demanded. Those, like Morris, who objected to Fried's denial 'that art should have . . . any kind of allusion to time or subject matter' and his insistence that art 'be very, very transcendent in one way or another – very removed from life', imbued their work with a kind of temporality which on the surface directly contradicted Fried's position (quoted in Alberro & Norvell, 2001 p.67).

While raising wholly legitimate concerns, arguably, Fried's adversaries have indiscriminately accepted the oppositional terms of the debate as he established it. Fer, for example, notes that despite the widespread influence of Kubler's 1962 book, *The Shape of Time*, which presented durational time as a multi-faceted phenomenon, Fried's own interpretation was to inaugurate 'a singular and monolithic sense of duration, so as to give greater emphasis to his own opposition between duration and that moment of "presentness"'. Importantly, she continues: 'This binary opposition has tended to stick even when commentators have taken issue with Fried's critical purpose' (2000 pp.71-72). Hence, where Fried argues for an atemporal aesthetic, opponents of his thesis merely invert the equation and advocate the kind of continuous and situational temporality he rejects. Recalling work from the late 1960s and early 1970s, Adrian Piper, for instance, writes of her intention 'to explore objects . . . in new conceptual and spacio-temporal matrices', and to 'draw attention to the spacio-temporal matrices in which they're embedded' as an antithesis to Friedian 'abstract atemporality' (1999 p.424). Capturing the *zeitgeist*, Burton's review of experimental work at the Whitney and Guggenheim in the summer of 1969 observed this 'alignment or identification of the viewer's time with the work's. The two became continuous; the fictive

time of art gives way to *our* time, to "real" time' (1969 p.40). The itali-
cised use of the word 'our' is no accident. It encapsulates the ideal of a
participatory and *inc*lusive art in contrast to the *exc*lusive 'bourgeois'
experience Fried had outlined in Art and Objecthood.

Art which embodied a sense of durational time, the kind of spacio-
temporality Fried identified in 'literalism' – "real" time – thus became
synonymous with "real" life and the "real" world. Michelson, for example,
argued of Morris's work that 'its comprehension not only demands time;
*it elicits the acknowledgment of temporality as the condition or medium
of human cognition and aesthetic experience*' (1969 p.23). Likewise,
Burton's review appropriated Fried's vocabulary while subverting his
thesis. 'Temporal dimension', he writes, 'is crucial to both concept and
appearance. All art exists in time, of course, like everything else'. In the
comments which followed, the reviewer identified an embryonic Conceptual
Art, emerging from its Minimalist roots and defined by a new-found,
self-conscious celebration of durational temporality:

> Perversely, artists, trained in the reorganisation of physical
> matter to produce art objects, are today going against the grain
> of their mediums, so that what was once painting and sculpture
> has now become as important for duration in time as for
> location in space. "Literalism" has been extended to modes
> of temporal existence (1969 p.40).

Hence, if Fried defined Modernism against 'theatricality'; against
'the subjugation of the artwork to a temporality not belonging to it', and
despaired at 'the experience of the object [which] maintains the normal
temporality of the viewer, who really seeks the suspension of time in
pursuit of "presentness"', the emerging avant-garde claimed situational
temporality – "real time" – as it's *raison d'etre* (Brockelman, 1993 p.52).
However, the concept of durational time itself is problematic. The choice
of vocabulary adopted by Fried's critics indicates a spurious, ill-defined,
universal and commonsense notion connoting vaguely democratic princi-
ples. Brockelman for instance, speaks of 'the normal temporality of the
viewer' and of how 'presentness stands forth against the denial of our
everyday temporality' (1993 p.52 & p.58, my emphasis). Meyer describes
the 'spectatorship of literal objects occurring in *real* time and space'
(2000 p.82, my emphasis). Foster (1986), as noted previously, refers to
'mundane time', and Smithson in his letter to *Artforum* accuses Fried
of being 'a naturalist who attacks *natural* time' (1967 p.4, my empha-
sis). Nevertheless, the philosophical significance of 'normal', 'everyday',
'real', 'mundane' and 'natural' time remains unquestioned.

The Philosophical Origins of "Real" Time

> For time is just this – number of motion in respect of 'before'
> and 'after'.

> *Clearly then 'to be in time' has the same meaning for other*
> *things also, namely, that their being should be measured by time ...*
> *Now, since time is number, the 'now' and the 'before' and the*
> *like are in time, just as 'unit' and 'odd' and 'even' are in number,*
> *i.e. in the sense that the one set belongs to number, the other*
> *to time. But things are in time as they are in number. If this is so,*
> *they are contained in time as things in place are contained in place.*
> *...A thing, then, will be affected by time, just as we are accustomed*
> *to say that time wastes things away, and that all things grow old*
> *through time, and that there is oblivion owing to the lapse of time,*
> *but we do not say the same of getting to know or of becoming young*
> *or fair. For time is by its nature the cause rather of decay, since it*
> *is the number of changes, and change removes what is (Aristotle's*
> Physics IV, *quoted in Stambaugh, 1990 p.69).*

Arguably, the concept of durational or "real" time articulated by Fried and advanced by his critics, can be traced to its ancient Greek origins in Aristotle, via Newtonian seventeenth century scientific philosophy. Condensing Aristotle's theory of time quoted above, Stambaugh identifies three core principles. Firstly, time is perceived to function like a 'container', a repository which hold or frames things: 'Time is separate from the things in it; it contains those things in a way analogous to the way space contains the things in it'. Secondly, time is synonymous with measurement: 'Time is essentially calculation, calculating motion or change with respect to before and after'. Thirdly: 'Time is the instrument or cause of decay and destruction, eventually destroying what is in it' (1990 p.69).

In the first instance, the container analogy of time is evidenced in Fried's choice of vocabulary; 'persistence', 'duration' and 'continuousness', and in his statement that the Minimalist experience '*persists in time*, the presentiment of endlessness which . . . is central to literalist art and theory is essentially a presentiment of endless, or indefinite, *duration*' (1967 p.22, my emphasis). This 'idea that things are in time', Stambaugh argues, is 'almost ubiquitous' and reaches a pinnacle with Newtonian philosophy. Such an understanding of temporality is based, she continues, on the notion that time is a 'static container *in which* events occur' (1990 p.25). For Fried, it is what prescribes the boundary for the encounter between beholder and object. In a sense, 'theatricality' becomes a metaphor for common-sense time. It is the 'container' in which things happen: 'Theatre is the common denominator that binds a large and seemingly disparate variety of activities to one another' (1967 p.21). Thus, 'theatrical' time is merely another version of what Aristotle describes as things existing 'in time as they are in number . . . contained in time as things in place are contained in space'. Moreover, as with Aristotle's spacio-temporal location, time in Newtonian terms is also *situational*:

> *times and spaces are, as it were, the places as well as of them-*
> *selves as of all other things. All things are placed in time as*
> *to order of succession; and in space as to order of situation.*

> It is from their essence or nature that they are places
> (quoted in Stambaugh, 1990 p.65)

Consider now Fried's statement that 'the experience of literalist art is of an object *in a situation* – one which virtually by definition, *includes the beholder*' (1967 p.15). In both cases time is a place that circumscribes the location of people, objects and events.

Next, Stambaugh notes that 'Time – and ultimately eternity as its counterpart, [Fried's durationless, instantaneous presentness] as what "overcomes" time – has been almost exclusively conceived in *quantitative* terms' (1990 p.68). Again, Fried's characterisation of literalist temporality is not incompatible with Newton's interpretation of Aristotle's second principle that 'Time is . . . number of motion in respect of 'before' and 'after' . . . being should be measured by time'. When reflecting on Tony Smith's account of his journey; 'The constant onrush of the road, the simultaneous recession' of the passing urban landscape which so concerns Fried, is the very same passage or flow of time central to Newton's rendition of 'common time' which amounts to a 'measure of duration by means of motion . . . such as an hour, a day, a month, a year' (quoted in Stambaugh, 1990 p.65).

From a Newtonian perspective, the juxtaposition of time as a framing device with the idea of time as measure leads to a somewhat awkward and ambiguous coexistence; 'here we have a picture of time as the immovable place in which things occur, a container, and as something flowing equably' (Stambaugh, 1990 p.66). This ambivalence is mirrored in Fried's text. As well as the object and viewer being 'suspended' in time, so too time apparently flows forwards and backwards. Witness his statement that: 'the sense which, at bottom, theatre addresses is a sense of temporality, of time both passing and to come, *simultaneously approaching and receding*' (Fried, 1967 p.22).

The confusion Stambaugh identifies 'as to whether time is the static container in which events occur or whether it is itself what occurs in a linear succession running from the future into the past', is further exacerbated by the fact that time 'is often conceived of as starting with birth and progressing forward inevitably to death, which can terminate the forward progression at any time and must do so eventually' (1990 p.25). The sense of time 'progressing forward' towards death completes Aristotle's third component of ordinary temporality in which 'time wastes things away . . . For time is by its nature the cause rather of decay, since it is the number of changes, and change removes what is'.

If Fried confirms an initial suspicion that a common-sense understanding of "real" or durational time has an Aristotelian complexion, his critics corroborate this supposition by overtly linking durational time with death

and decay. Smithson, for example, in his thinly veiled critique of Art and Objecthood, argues that 'Many [i.e., Fried and colleagues] would like to forget time altogether, because it conceals the "death principle"' (1968, p.50). Thus, to remember time, is also to *remember* or confront death. Wood makes the same association, arguing that Fried's appreciation of Kenneth Noland, Jules Olitski and Frank Stella's paintings was based on the fact that they offered a transcendental experience: 'one could be carried by it into a state of "grace", and by implication out of the world of time, death and decay' (2002 p.31). If, therefore, Fried's timeless, atemporal realm is *out* of this world, *beyond* 'death and decay', then durational temporality must be located conversely *in* this world, defined in terms of death and decay. Hence, instead of concealing the 'death principle', "common-sense" or "real" time reveals it.

Similarly, the implications of Brockelman's terminology when he speaks of the 'denial of a *continuous* temporality' and the 'removal from temporal *progression*' of the artwork in Fried's thesis, clearly represents the perspective of those seeking to critique formalist aesthetics and establish a different concept of time for both artistic practice and criticism (1993 p.59, my emphasis). This alternative temporality is durational; it flows. Moreover, it is a motion *towards* something, as signalled by the word 'progression'; essentially, a movement towards death. Despite being keen to reinstate the polyvalent dimensions of durational time, Fer further reinforces this interpretation in her comments on Smithson's 1996 essay; The Crystal Land, in which the artist discusses a work by Donald Judd. His take on the piece, she states, expresses the work's 'conscious durations, indelibly casting it in the direction of death' (2000 p.73).

In sum, the assumptions implicit in the common-sense durational understanding of time, framed by both Fried and his critics, in opposition to the atemporal, 'instantaneous presentness' of modernist art, envisage time as a place or 'container' in which things happen. Furthermore, time is a mode of measurement and calculation and flows in a linear, sequential direction, irreversibly from birth to death.

As Time Goes By: Three Strategies of Ephemeral Art

My contention is that a hegemonic construction of ephemeral art becomes constituted through a particularly nihilistic understanding of impermanence, founded upon the Aristotelian principles outlined above; a legacy which continues to find expression in elements of Neo-/Post-Conceptual practices to date. The following three sub-sections each identify the key features of the ephemeral strategies: *Dissolution, Dispersal and Decay*, introducing and analysing relevant examples, demonstrating how these strategies actualise the three principles of Aristotle's theory of time.

Strategy One: Dissolution

The reduction of material by melting or dissolving typically character-ises this strategy. Solid three-dimensional sculptures or embossed relief works, crafted with ice, snow or wax are erased; transformed from a defined mass to an amorphous uncontainable liquid state. Allan Kaprow's (1967) ice-based event *Fluids* is cited by Godfrey as a precursor to much of the process-led work appearing in the following years which engaged specifically with 'the concepts of disappearance, impermanence, change and destruction' (1998 p. 160). By linking 'impermanence' with 'disap-pearance' and 'destruction', Godfrey indicates the Aristotelian principles at work. The sense that time wastes things away literally flows through these pieces. Moreover, the word 'change', anticipates Aristotle's precept that time is the measure of things, of motion, and is demarcated by states of 'before' and 'after'.

Other commentators similarly implicate themselves in this understanding of time. Tarsia's assessment of the British artist, Bruce McLean, who took up the thread of site-specific ice works in the urban environment, is a case in point. Her statement that McLean's series *Vertical Ice Sculptures* (1967), 'occupy an ultimately finite spatial and temporal dimension' is symptomatic of the way in which the concept of ephemerality both in this and the following strategies is discussed, namely; as a process of extinction (2000 p. 19). Where time is construed as the cause of decay and destruction, impermanence becomes constructed around the passing away of things and associated with finitude. Thus, in McLean's work, for example, the sense in which the ice is absorbed by the canal water, which in turn flows into a river, and river into sea, is lost. The transition from sculpture to non-sculpture, from ice to water, form to formlessness is demarcated as the *ending* of something rather than one phase of identity in a larger, ever-changing whole.

Paul Kos' sculpture *Richmond Glacier* (1969), comprising 7,000 pounds of ice and salt blocks, measuring 60 x 60 x 60 feet, sited directly outside the main entrance of the Richmond Art Centre, California, preventing access, is also discussed in terms of disappearance. Meyers argues that contrary to appearances, the ice functioned not so much as a 'barrier' but as a 'threshold' . . . 'existing – precariously – along a razor's edge of form and decay. On a hot summer's day, it has already lost the battle' (2003 p. 97). To speak of a 'threshold', positions the work symbolically between life and death, at the edge of an abyss: a void. Life itself is the 'battle' lost. Hence, the sub-text reads; form disintegrates as time decays the substances it "contains".

Continuing this theme Kos staged *The Sound of Ice Melting* (1970), a floor sculpture installed in the Museum of Conceptual Art consisting of

two enormous ice cubes each weighing 25 pounds, encircled by high-tech microphones recording the noise or absence of noise as the object gradually disappeared. Similarly, Kos' pen and ink drawings titled *Kinetic Ice Block (salted top)* (1969), document six phases in the dissolution of another large ice sculpture; *Untitled (kinetic ice block with salt)* (1969) the upper surface of which was liberally sprinkled with salt. His record is a testimony to the serial relation embedded in Aristotelian time. Durational temporality is represented diagrammatically in stages. Stage one shows a perfectly illustrated cube with each successive image depicting the cube gradually diminished in size. By stage six the ice has wasted away to a pool of water. Kos's thin black horizontal pen line denotes the remaining puddle; the object's absence. Kos further references the reductive quality of time in a hand-written text at the base of his sketch illustrating *Kinetic Ice Sculpture* (1969). Here, a block of ice systematically melts on its descent down a stepped incline 'all the time diminishing in scale by friction, environmental temperature and time' until reduced to an isolated drip at the lowest point. Significantly, the artist's final note concludes that the piece signifies 'the antithesis of the myth of Sisyphus' (quoted in Meyers, 2003 p. 102, my emphasis). In rejecting the circular time to which Sisyphus is 'condemned', Kos subscribes to a linear temporality from which nothing can be resurrected.

Like Kos' work, elements of Dennis Oppenheim's snow performance/installation pieces also depend upon a concept of impermanence deter-mined by duration in which time devours the things it contains leaving only a void. One specific work from his *Gallery Transplant* series (1969), a collaboration with Cornell University sited in an adjacent bird sanctuary, mapped out the architectural gallery plans in the snow and represented a targeted political critique of the art institution. McEvilley's interpretation of this raises pertinent issues. He writes:

> *Various works of the period investigated citing art within the agricultural and climatic time cycles of nature. **The Gallery Transplant** in the bird sanctuary, for example, was done in winter and disappeared when the snow melted. It was like a part of nature in other words, and passed with the changing of the seasons..... Such pieces flaunted both their ephemerality and their conditionality, operating against the Modernist crypto-religious belief in the artwork as eternal and autonomous like a Platonic Idea. The work is subject to the conditions of nature like everything else, in opposition to Modernist work, which was conceived as outside nature and not susceptible to its rhythms of change and decay (1992 p. 20).*

Accepting that the 'crypto-religious' Modernist is a thinly disguised reference to, and attack on Fried's position as symbolised by Art and Objecthood, 'nature' becomes a euphemism for the kind of durational

time despised by adherents of formalist aesthetics. As such, 'change and decay' are reminiscent of the two Aristotelian principles of time which reference time as quantification and as the cause of destruction. Moreover, despite McEvilley's claim to the contrary, in this linear narrative Oppenheim's pieces has no commonality with the cyclical time of nature, for where nature's annual ritual contains the seeds of its own rebirth, *Gallery Transplant* does not posses any such feature. Snow may well fall again but the artwork's disappearance in time is absolute and finite. Snow will never again settle in Oppenheim's embossed patterns without further artistic agency. Hence, the critic might well have written 'The work of art is subject to the conditions of *time*', in the sense of "natural", or "real" time discussed earlier.

In the art of *Dissolution*, time is perceived as sweeping everything into oblivion; procured through the specific act of heating a solid substance to the point of liquefaction. Whether through exposure to ambient temperature, as in the case of ice and snow sculptures, or by more intensive artificial methods such as *Aging* (1974); Oppenheim's installation of wax dummies, lined up against a wall at varying distances from infra-red heat sources, the end game is the same. A catalogue accompanying *The Snow Show*, a recent exhibition in Lapland, suggest that such interpretations of ephemerality remain prevalent. In the words of one contributor 'snow/ice is the material of lack' (Fung, 2005 p.156).

Strategy Two: Dispersal

The second strategy, *Dispersal*, denotes the scattering and dissipation of a material substance to achieve the breakdown and eventual eradication of the object. The proclivity of artists here is towards the use of particulate matter such as dust, graphite, chalk, flour, soil, salt, sand, sawdust and dry pigment. Lothar Baumgarten's pigment pyramids - *Tetrahedron (Pyramid)*, (1968), from a series comprising cobalt blue pigment placed in piles on a concrete floor, and *Stacked Pyramid*, (1968), a red pigment pyramid located on a forest pathway, are subject to natural forces of dispersal. Rorimer reports that 'After a number of weeks, these geometric shapes fall apart of their own accord. If touched they disintegrate into a pile of dust'. Her further comment that Baumgarten's pigment pieces 'made the process of time visible' assumes not only that time is a process; a movement *towards* something, but also, that this process is one of decay and disintegration (2001 p.259). Once again, ephemeral art and the critical language employed to discuss it are inscribed with certain Aristotelian suppositions about what time is and the way in which it functions; in this instance, that time is the cause of death and decay, marching forward in a linear fashion destroying all contained within it.

Another example is an untitled work from Marcel Broodthaers' expansive project *Musée d' Art Moderne, Départment des Aigles* (1970). Paralleling Oppenheim's *Gallery Transplant* series, the artist, in collaboration with Herman Daled, drew a temporary museum plan in the sand on the beach at Le Coq, later washed away by the tide. William Wegman's *OR* (1969) and Jan Dibbets *12 Hours Tide Objects with Correction of Perspective* (1969) epitomize other beach-based works subject to environmental dispersal. The former involved the artist visiting a number of coastal locations in Maine and marking out the word 'OR' with sprinkled masonite dust at each site. Dibbets' more ambitious but no less temporary piece was executed by physically ploughing lines into a sandy Dutch beach, an act transmitted on live television as part of Gary Schum's *Land Art* exhibition. In the accompanying catalogue Dibbets described the event thus: 'The project will be made at the beach when the water is low. It will be wiped out when the water is coming up again. It takes about eight hours (flood-tide) . . . When it is finished, the work of art no longer exists' (quoted in Kastner, 1998 p. 181). The duration of these works is determined by the tidal ebb and flow. Paradoxically, the cyclical lunar rhythms of the tide (an ancient, non-mechanical method of measuring time) are countered by the linear trajectory of the artwork, marking its erasure - it's disappearance by and 'in' time.

Human agency plays a greater role in determining the dispersal and longevity of the work in Jan Dibbets' *Sawdust Removal and Perspective Correction* (1967), part of a 24 hour exhibition of temporary art at Galerie Loehr, Frankfurt, which lasted just two hours, conforming to the exhibition subtitle: *19:45-21:55*. Rorimer describes the work as 'a sawdust ellipse on the courtyard cobblestones outside' which 'was gradually destroyed by throngs of visitors entering without heed to, or angry about the work underfoot' (2001 p.124).

In each strategy, photography is commonly used to document transience, subconsciously reinforcing the perception of time as measure, of cause and effect, by quantifying the deterioration and decay of matter suspended within it. The fact that Dibbets' photographed this piece every quarter of an hour augments this theory, since it is through the photograph itself that material change, transformation and destruction is systematically represented and quantified. Like Kos' drawings, each image forms part of a linear sequence endorsing both Aristotelian assumptions that time is durational *and* destructive.

Further examples are the late 1960's works of Bill Bollinger and Barry Le Va. Discussing his *Untitled (Studio Piece)*, (1968) comprising a 5ft square floor installation of sifted flour in *Avalanche* magazine, Le Va describes the work as '*marking off stages in time*', adding that 'I started using materials that were more ephemeral. Since chalk and flour were

easily dispersed' (1971 pp. 66-67, my emphasis). Such comments not only confirm the notion of time as measure but also closely tie the idea of ephemerality to particular types of material. Some materials are more ephemeral than others, Le Va implies, since their destruction in time is faster and therefore more readily observed and calculated in comparison with other more 'substantial' matter.

This theme is reiterated by different artists and critics across all three strategies. 'Material instability creates impermanence', writes Burton in an article, Time on Their Hands (1969 p.41). His review of Bollinger's *Graphite Dust* (1969) at the Bykert Gallery states that the artist's choice of materials propels the artwork 'a further step toward impermanence'. Thus, the ephemeral is once again conceived as a nihilistic phenomenon, spearheaded by disappearance; the cessation of material existence, of 'vacancy and absence' caused by the "passage" of time (Burton, 1969 p.42). Even more blatantly, Meyer's commentary extols Bollinger's work as 'a revolutionary statement leading into Satre's "Nothingness"' and 'a confrontation with the very non-existence of the object' (1969 p.21).

The work of contemporary artists such as Erwin Wurm, substantiate the fact that neither the strategy of *Dispersal*, nor the attendant perceptions of time can be written off as an antiquated aberration. Although the critical language has taken a postmodern turn, Wurm's dust 'sculptures' tangentially invoke the same concepts of time as measure, container and decay. Whether outside the museum, as a rectangular configuration of house dust spread over a New York street, or inside, posing as 'museum display cases from which the objects have been removed', leaving the imprint of the supposedly missing artefacts in stencilled dust patterns; ephemerality, three decades later continues to be articulated in terms of disappearance and void (Wäspe, 1996 p.12). Dufour's commentary is littered with such references: 'Absence and emptiness pervade these rudimentary constructions' . . . 'the imprint of the no longer present . . . the residual record of an action' . . . 'absence as a continuous theme' . . . 'trace evidence' . . . 'the absence of a body becomes equivalent to the form presented', and so on (1991 pp.33 & 34). Likewise, Wäspe's account links 'the temporal structure of the work' with 'the fading form' and 'the missing body' (1996 p.16). In his gallery pieces, Wurm's work performs a double disappearing act: once in the perceptual illusion which leads the audience to believe they are observing the detritus resulting from the removal of valuable historical artefacts, and again as environmental dust accumulates and settles during the course of the exhibition, obscuring the very traces or 'negative' spaces themselves. Thus, like Le Va, time 'marks off' the process of effacement. Despite contrasting methods and materials, these artists are united ideologically in counterpoising longevity with a concept of ephemerality defined by the artist as a process of disappearance in which time is the ultimate cause of destruction.

Strategy Three: Decay

This strategy is distinguished by decomposition and again, like the previous two, connotes a process leading to the ultimate disintegration of the artwork and its apparent disappearance over a given period of time. Here, artists appropriate the auto-catalytic behaviour of (mainly) organic substances such as foodstuffs, flowers and vegetable matter. There is a fatal inevitability built into work of this type, which depends upon the idea that time, in the end, will consume or 'remove' what is 'in' it. Aristotle's conviction that 'time wastes things away', quoted previously, is vividly manifest here. Each artwork begins life in pristine condition, until, subjected to the one-way passage of time, is visibly altered beyond recognition and eventually destroyed.

Zoe Leonard's *Strange Fruit (for David)* (1993-1998); a floor-based installation shown at Philadelphia Museum of Art in 1998, comprised the dried fruit skins and rinds of over 300 oranges, lemons, grapefruits, bananas and avocados strewn across a large space. Describing the process and appearance of the work, Temkin states:

> After the artist ate, or others had eaten, the meat of the fruit,
> Leonard allowed the skins to dry out and then 'repaired' and
> adorned them - literally sewing up the seam she had opened
> - with coloured thread, shiny wires, and buttons; bananas, for
> example, are neatly closed up with stitches or zippers that run
> from top to bottom (1999 p.45).

Decay lies at the heart of this work since 'The very essence of the piece is to decompose' (quoted in Buskirk, 2003 p. 145). Leonard states that she just wanted the fruit 'to have a room somewhere where I could install them and then leave them to be. Just let them decay' (quoted in Temkin, 1999 p. 46).

The time span of this piece is elongated to a few years, requiring the work to be revisited in order to observe and appreciate its more gradual disintegration. In recognition of this, Philadelphia Museum of Art, which purchased *Strange Fruit*, 'agreed to try . . . to show the piece for periods of time with a certain cylindrical regularity, which seemed in the spirit of the work's sense of marking time' (Temkin, 1999 p. 48). The concept of 'marking time' once more serves to highlight the quantifiable dimension of temporality, referenced earlier in Aristotle's statement, describing time as 'number of motion in respect to "before" and "after"', and proclaiming that 'being should be measured by time'. Paradoxically, time marches forwards in a linear fashion, causing the decay and destruction of the fruit it 'contains' while the cyclical display of the work references an entirely contrary understanding of temporality.

Decomposition is inevitable and despite Leonard's repairs to the fruit

skins in *Strange Fruit*, no amount of mending can prevent the artwork's demise. In addition to the physical aspect of decay and destruction, Buskirk notes how:

> the multiple references of the title – to the Billy Holiday song, with its powerful image of lynched bodies, to Leonard's friend, David Wojnarowicz, who died of AIDS in 1992, and to the pejorative use of the term "fruit" as slang for gay – suggest specific associations that support a general sense of loss (2003 p. 145).

The theme of 'loss' is reiterated in Anya Gallaccio's 1991 *preserve* (1991) flower series consisting of fresh flowers pressed between sheets of glass; yellow narcissi in *preserve cheerfulness*, 800 gerbera in *preserve beauty* and 101 sunflowers laid out side by side in rows in *preserve sunflowers*. In his essay: Loss is More: The Work of Anya Gallaccio, Watney suggests that 'gradual physical disintegration and eventual disappearance is fundamental to its effect' (2003 p.4). Chapman and Falconer also associate Gallaccio's ephemerality with 'tragedy' and the 'aesthetics of loss', although exceptionally, in contrast to other reviewers, they are critical of such a durational and nihilistic perception of time grounded in 'a succession of entities between beginning and ending' and the artist's 'use of temporal scale, calibrated by the diminishing moments of decay' (1994 p. 53).

The languid and melancholy transition from life to death witnessed in *Strange Fruit* is hastened in Gallaccio's decomposition series, providing the audience with a more immediate and spectacular experience. The work exists in a 'continual state of physical and aesthetic flux', played out over a period of days or weeks (Reitmaier, 2002 p. 44).

This measurable transition from being to nothingness is explicitly documented by Gallaccio in the "before" and "after" photographs of the *preserve beauty* series which record the duration of the gerbera's demise. Similarly, the process of decay in *preserve sunflower* is captured by four sequential images reproduced in *Chasing Rainbows*, depicting imperma-nence as a linear life to death trajectory; from vibrant yellow petals to mushy blackened remains. As Watney reports, Gallaccio's flowers wilt, fade and 'rot down slowly into a kind of putrefied marmalade, the reassuring olfactory pleasures of scent replaced by the festering stench of decay' (2003 p.6). Hence, despite Rugoff's insistence that Gallaccio's ' decomposing flowers do not conjure death and extinction' but instead focus one's attention on 'transformative processes', it is a series of trans-formations which invariably *conclude* with death and extinction (1999 p.12). Moreover, the critic points out that Gallaccio's artworks are 'archived with two sets of dates; of destruction as well as creation', confirming the finality of such processes (Rugoff, 1999 p.13).

Significantly, in his consideration of Gallaccio's practice, Rugoff invokes

Fried's text, Art and Objecthood, clearly aligning himself with the kind of temporality advanced by Fried's critics, celebrating the 'real time' aspect of her work, referencing one moment in a linear series of moments, demarcated by the '"here today, gone tomorrow" status' of the work (1999 p. 12). Rugoff's comments endorse the argument outlined earlier, which connect the historical origins of ephemeral art with a particular way of thinking about time. He writes:

> if temporality was implicit in Minimalism, [the focus of Fried's critique] it soon became an explicit part of the vocabulary used by performance and conceptual artists . . . who created site-based works of limited duration – a tradition to which Gallaccio is an heir (1999 p. 12-13).

Two final examples are sculptural items of clothing from a triptych by the artist Savage: *The Unattended Funeral* (1997), a jacket saturated with cultivated mould, rendered seductively attractive by its velvety texture and shades of mint green, turquoise and duck egg blue, lies poised between the needle and teeth of an old-fashioned hand sewing machine, and *Dorian* (1997), a similar garment, hanging from a solitary wire coat hanger. The complete triptych, alongside fourteen other works by the artist, was installed at Bristol City Museum and Art Gallery during the winter of 2000/2001 in an artistic intervention entitled a *nice cup of tea (& other fragments)*.

Like Leonard and Gallaccio's work, the demise of these pieces is guaranteed as the interaction between the mould and the textile renders them precarious, unstable and unwearable. According to the artist, other mould works 'are now completely lost because they have deteriorated or been eaten by bugs', and Savage openly informs private collectors that he is unable to guarantee the longevity of the work. In his terms, impermanent art is by definition, 'artwork which will die because everything dies. Everything has a lifespan' and therefore, 'ephemerality is a process'. However, it is a process moving inexorably towards death. 'Ephemerality', he goes on to argue, 'is a human thing . . . it relates to human concerns . . . so anything that a human creates or works with or touches, will no doubt suffer from ephemerality in the end' (2002a). The notion that ephemerality is something that we 'suffer from' recalls Stambaugh's earlier summation of impermanence as a concept based on a durational perception of time: 'Birth is the inception of a life that extends over a period of time and terminates in death' (1990 p.72). Implicit in the title of Savage's jacket, *Dorian* – a blatant reference to Oscar Wilde's novel *The Picture of Dorian Gray* - is the notion that time is the agent of destruction and a quantifiable process. Alluding to his own youthful participation in a drug and club subculture, Savage reflects: 'I *was* Dorian . . . whilst my jacket, my real persona, was taking on all the ageing of life' (2002b). Hence the decaying jacket functions as both a metaphor and a literal representation of the

the idea that time wastes things away, as the effects of a decadent lifestyle are physically and symbolically manifest in the garment's deterioration over time.

Despite strategic differences in method and material, all three complexions of ephemeral art examined here are united by a common understanding of impermanence derived from an Aristotelian conception of time. The actual disappearance, decay and destruction wrought upon the material artwork as time wastes away the things it contains constitutes a linear and irreversible process from something to nothing, from being to non-being. Moreover it is a transition which is calculable in terms of before and after. Time is measure. As such, the progression of this wastage - the linear temporal slippage – is frequently quantified in sequential drawings and photographic documentation. Upon this notion of time and impermanence, the kind of ephemeral art examined here has built its critique.

Ephemeral Art & the Museum: Critique or Collusion?

In his article Impossible Art, Messer vilifies the spread of the kind of impermanent artworks described above, and the particular challenges they present to the conservation profession, identifying the:

> *extreme fragility of objects evidently possessed of a death*
> *wish and thus capable of thwarting the most ingenious efforts*
> *of a skilled and technically proficient cast of conservators*
> *- a fragility that eventually moves towards invisibility,*
> *disembodiment and sheer non-existence.*

The author, (then director of the Guggenheim Museum), goes on to argue that such art interrogates 'the entire intermediary machinery consisting of dealers, critics and museums' and 'will not support institutions or galleries, for it will most likely not be bought or sold'. Furthermore, 'through absence, negation and unwieldiness [it] assumes a threatening posture toward the art establishment' (1969 p.31). On this basis it would seem that the kinds of ephemeral art cited above are implicitly subversive.

Focussing on *Decay* as an exemplary strategy, the capacity of ephemeral art to function as a critique is apparently borne out by the often tense relationship between these artworks and the institution. The efficacy of Gallaccio's work, for example, depends on the rapid properties of decay inherent in the organic materials she selects, which, of *themselves*, present a challenge to the institution because they 'test the knowledge and patience of conservators' (Horlock, 2002 p. 11). As Schama writes, her practice utilizes 'the mutability of nature as the essence of its resistance to the museum aesthetic' (2002 p. 22). Where the *raison d'etre* of the institution depends on a tacit understanding that the art object should be permanent, that its existence should be preserved for future generations, and therefore where its function is to guard against anything

which interferes with that durability, an encounter with objects and practices predicated on an entirely antithetical value system is deemed threatening. Working alongside Gallaccio on *Beat*, a recent installation at Tate Britain, Horlock, a museum employee, recounts her anxieties: 'I noted with some relief that these materials were mutable but not in such a dramatic way as ice or flowers', however, she remained concerned about 'the worrying implications for other works of art nearby' (2002 p. 12). Gallaccio thus positions herself as an *agent provocateur*, threatening the longevity of traditional artworks via their mere proximity to her own impermanent offerings.

Leonard's *Strange Fruit* attacks the institutions' Achilles heel from another angle, raising issues about cataloguing, classification and the storage requirements placed on conservators. Temkin, a curator of twentieth century art at Philadelphia Museum of Art, directly involved with the work, outlines:

> the discomfort some [colleagues] had in assigning it an
> acquisition number. How can you give a number to something
> that won't always be there? To me this revealed our collective
> belief in the sense of permanence bestowed by an inventory
> (1999 p. 48).

She goes on to reveal conservators' attitudes to the ephemeral as a sickness requiring treatment, stating that *Strange Fruit* is 'an affront to the whole profession. It is like bringing to a surgeon a patient with an inoperable disease' (1999 p. 49). This work is an exceptional example of ephemeral art in that the museum actually purchased the piece, a controversial transaction which almost failed to materialize due to the sensitive conservation issues it raised. Museum acquisition policies state specifically that objects collected should be of a permanent nature. For example, in section 3.1 under 'Acquisitions to Museum Collections', the International Council of Museums (ICOM) *Code of Professional Ethics* (2001) pronounces that a museum's collection policy 'should state clearly the areas of proposed collecting and include guidelines for maintaining the collection in perpetuity' and places 'a restriction against acquiring material that cannot be catalogued, conserved, stored or exhibited properly'. The following paragraph continues: 'All objects acquired should be consistent with the objectives defined in the collection policy and selected with the expectation of permanency and not for eventual disposal'.

Savage also adopts a provocative attitude towards the museum. He describes his work as 'rather subversive', because it 'literally infiltrated the museum. The curators would always eye you with deepest suspicion. There was a concern that I was going to make a mockery of the profession . . . What do you not want in a museum? Mould!' (2002a). Again, the institution's mounting anxieties were expressed in direct relation to the material properties of the work. David Singleton, Registration & Assessment

Officer in the conservation department at the museum, reflecting upon the arrival of *Dorian* and *The Unattended Funeral*, recalls observing 'all the material that was coming in, including a lot of organic material quite likely to house pests of one sort or another'. He continues:

> *We were concerned about the amount of mould spores that could be deposited, even though it wouldn't normally be damp enough in the museum that anything would happen to them. By the time I arrived and took up the post it was too late (2002).*

Singleton described a variety of preventative treatments which could theoretically have been applied to the triptych, ranging from placing the jackets in a carbon dioxide bubble, to fumigation and blast freezing. All had problems, the main one being the sheer lack of time available before the exhibition opened. In the event, the conservation department decided to place 'anything that was remotely dubious' into sealed glass cabinets and set up a strict monitoring programme. *Dorian* and *The Unattended Funeral* had only been on display for a matter of days when webbing clothes moths were spotted.

The immediate ejection of Savage's work as the institutional response to this potentially devastating insect infestation, serves to illustrate how ephemeral art, at least on one level, offers a challenge to the ideology of the museum, albeit, in this case, a purely unintentional one by the artist. From a conservation perspective the incident reaffirmed the department's belief that preventative conservation is essential:

> *It's a shame that there wasn't somebody in post at the time this exhibition was organized . . . Arriving to find that a potential disaster occurred because my job wasn't filled proved that my job was necessary (2002).*

Questioned as to how he felt about ephemeral art being admitted into the museum, Singleton reiterated throughout the interview that despite being challenging, he was: 'very happy with it, provided, *obviously, that we* [conservators] *are involved from the very beginning*' (my emphasis). It became clear that the reason he didn't object to work of this nature being on the premises, hinged on the fact that the conservation department had it in their power to control its behaviour: 'if we considered it too dangerous we would have to stop it' (2002). In other words, anything is welcome in the museum on the condition that its ephemeral status can be anaesthetized prior to entry.

Education Officer and co-organizer of *a nice cup of tea*, Sandra Stancliffe, confessed that the whole event had instigated 'quite drastic' changes in policy and procedure:

> *We are very, very rigorous now. A curator and conservator are involved in appraising the work before it comes into the museum [especially] if it's the work of an artist. We've got a*

*set of clear exhibition procedures that are followed and
applied to everything that's brought into the museum, whether
it's the work of a practising professional artist or not. That has
changed the way we work. It's a lot more effective now (2002).*

In effect, Savage's intervention served to reinforce existing values and beliefs through tightening up policy and practice, ensuring that the museum continues to fulfil its functions, more stringently than ever. From the Savage's point of view, the museum are 'never going to let anything ephemeral in again . . . well, not unless it's been freeze-dried and nuked first' (2002b).

These statements illustrate the seemingly transgressive nature of this strategy. Out of place, behaving in unpredictable and undesirable ways (from the museum's perspective), such work perplexes professionals and challenges the established ideology of the institution. However, while ephemeral art strategies under discussion, albeit from the opposite end of the spectrum. Despite apparent irreconcilability, there is no significant divergence between the institutions' understanding of time and that of an artist like Savage. Both presuppose a common conception of time as measure; as persisting and substantial (the container analogy), and as durational (linear, sequential and irreversible). The only genuine discrepancy lies in the diametrically opposed responses to this state of affairs by each party. The conservator will call upon a wide range of scientific procedures to calculate, for example, the deleterious effect of environmental agents such as humidity, light, temperature and air pollution upon the artwork, in order to devise controlled interventions designed to counteract the cause of decay and destruction "by" time[2]. By contrast, the artist makes this quantification the *raison d'etre* of their work, celebrating the 'effects' of time. As Savage states, unlike the museum environment in which conservators are 'constantly fighting the degradation of materials by bugs and light, by anything . . . I just accept the inevitable' (2002a). From this perspective it could be argued that the function of the museum, through preservation and conservation, is to *conceal* the nature of time, whereas the purpose of ephemeral art is to *reveal* it. The nature of time itself however, is never in question. The second problem arises from this oversight; namely that the Aristotelian conception of time at stake and the consequent construction of ephemerality which emerges, is fundamentally dualistic.

[2]It should be noted, however, that within the conservation profession there exists a broad range of opinion both about the ethics of preserving ephemeral artworks and even whether they have a legitimate place in the museum at all. These arguments are outlined in Corzo (1999), Hummelen & Sillé (1999) and Heuman (1995).

Duality and Aristotelian Time

What is meant by the term "duality"? How does Aristotelian temporality evidence such dualism? And how is this understanding of time manifested in practice, both within the three ephemeral strategies as well as within the museum?

In his comparative study of Asian philosophies, Loy defines duality as a cumulative and tripartite concept. A dualistic interpretation of the world, he argues, is firstly dependent upon dualistic thinking or conceptual thought 'which differentiates that-which-is-thought-about into two opposed categories: being and non-being, success and failure, life and death, enlightenment and delusion' (1988 p.18). Dualistic thinking gives rise to the second form of duality; viewing the world from a pluralistic perspective, based on the conception that things in the world are separate, self-existing entities. This leads to the third type of duality; the bifurcation of subject and object which Loy explains as 'an experiencing self that is distinct from what is experienced, be it sense-object, physical action, or mental event' (1988 p. 25-26).

Dualistic Thinking in Aristotelian Time

An inescapable consequence of dualistic thinking is the paradox that attempting to favour one concept at the expense of another, inadvertently gives credence to the opposite:

> the problem with such thinking is that, although distinctions
> are usually made in order to choose one or the other, we can
> not take one without the other since they are interdependent;
> in affirming one half of the duality we maintain the other as well.
> (Loy, 1988 p.18)

The same phenomenon is witnessed in Aristotle's understanding of time and its manifestation in ephemeral art and the museum. Unintentionally, each ideology authenticates the other. For instance, the notion that time functions like a container validates a form of dualistic thinking via the concept of causation, engendering the oppositional categories of cause and effect, before and after. If 'causation itself requires a kind of continuous substratum to guarantee the connection between cause and effect', Aristotle's conception of time as a universal, persistent and substantial entity provides just such a 'continuous substratum' (Stambaugh, 1990 p. 60). This is exemplified in the strategies of *Dissolution, Dispersal and Decay*, where time functions as the *cause* of decay and destruction. Death – the death of the object – is its *effect*. Without the institutions' unfailing pursuit of the immortality of art via conservation, there would be no basis for artists to contrarily protest the artwork as a *mortal* entity.

There is no fundamental difference between the institutional conception of time expressed in the desire to collect and preserve objects 'as

ongoing attempt to cope with the fact that time goes by', and the creators of ephemeral art who have traditionally pursued their critique by targeting the material existence of the object itself, ensuring its disappearance through decay, dissolution, dispersal, and so on. Winzen goes on to cite two quotations which confirm this shared durational and dualistic perception of time: Hoderlein's statement that 'Time is constantly being lost', and Adorno's argument that 'The will to possess reflects time as a fear of loss, of the irretrievable nature of everything' and that 'What is, is experienced in relation to its potential non-existence' (1998 p.22 and p.23). Thus, while the artist may protest their intention to *confront* the 'fear' of mortality head-on rather than to evade it, it is precisely the 'potential non-existence' of the object through which they have chosen to articulate their critique. In other words, aspiring to permanence and eternal life is simply replaced by aspiring to abject nihilistic impermanence. As such, work of this nature invariably fails to challenge the ideological framework and the assumptions about time inherent in the discipline and practice of conservation. It is merely a reactive response.

The notion that time is calculation, actively nurtures similar conceptual oppositions. Dividing temporality up into separate points on a linear scale immediately generates the mutually exclusive notions of past and future. Thus, as the quantifier of 'motion or change', when combined with the Aristotelian principle that time wastes things away, time becomes a measure of the transition from one disconnected state to another. Significantly, time is not merely a measure of some unspecified altered state, but of decay and destruction – the specific change brought about by time. From this perspective, birth (or life) and death, as Stambaugh (1990) points out, are conceptualised as two opposing points on a linear time-scale with a calculable duration between them, birth being conceived as a beginning "in" time and death as an end.

This corresponds to the understanding of ephemerality advanced in the previous section, defined as the measurable duration between the inception of an artwork and its demise through various means of decomposition or dissipation to the point of non-existence, leading Temkin to observe that contemporary art is preoccupied with a discourse of 'disappearance' and 'absence' (1999 p. 47). Goldstein and Rorimer typically allude to this in their discussion of Baumgarten's pigment pyramids, arguing that his work 'privileged perishability over portability and the temporal over the timeless' (1995 p.74). As such, the critics reinforce the dichotomy between permanence and impermanence, clearly aligning ephemerality – 'the temporal' – with death, decay and the ultimate demise of the object through 'perishability'. Neither is the art establishment exempt from such charges. Both the bifurcation of birth and death, and of impermanence, in the nihilistic sense, and permanence, meaning eternalism, signify the kind of dualistic thinking around which the Getty Conservation Institute

successfully framed its 1998 Los Angeles conference: *Mortality/Immortality?
The Legacy of 20th-Century Art*[3].

A Pluralistic World in Aristotelian Time

The consequence of mentally dividing the world up into distinct catego-
ries facilitates a common-sense dualistic approach to "things", character-
ised, according to Loy, by the understanding that 'a physical object is self-
existent', meaning 'it has an existence of its own which is not dependent
on other objects or on subjects (a consciousness that is aware "of" it),
although it may be affected by them'. Moreover, he continues, 'A corollary .
. . is that the object tends to persist unchanged unless affected externally
by something' (1988 p. 75). In this instance, that external 'something' is
time itself. The dualistic thinking which erects a division between imper-
manence and permanence, reinforces a pluralistic view of the world, for
while what happens "in" time is rendered temporary due to the cause/
effect factor, time itself is envisioned as an absolute, 'continuous' and
eternal phenomenon. Time ends the things "within" it, but time itself is
everlasting. As a substantial and objectified entity, time appears to
exist independently, 'separate from the things in it' and 'contains those
things', thus creating an opposition between the container (time) and the
contained (the objects within it):

> in order for time to be a container, something must be con
> tained within it: objects. And for objects to be "in" time,
> they must in themselves be non-temporal - i.e., self-
> existing. In this way a delusive bifurcation occurs between
> time and "things" generally, as a result of which each gain
> a spurious reality (1988 p. 219-220).

From the museum's perspective, the notion of a 'non-temporal',
'self-existing' object is firmly enshrined within conservation ethics.
Professional codes issued by the International Council of Museum's (ICOM,
2001), the European Confederation of Conservator-Restorers' Organisa-
tions (ECCO, 2002), the Canadian Association for Conservation of Cultural
Property and the Canadian Association of Professional Conservators (CAC
& CAPC, 2000), the Australian Institute for the Conservation of Cultural
Material (AICCM, 1986) and the United Kingdom Institute for Conservation
(UKIC 1996) all make reference to the 'integrity' or 'authenticity' of the
object. Discussing the concept of integrity, Clavir argues that:

> If the goal of conservation can be said to be the safeguarding
> or preservation of material cultural heritage, the objective is
> to do this within an ethical framework which ensures that the
> intrinsic nature of the object is not altered (1998 p. 1).

[3]See Corzo (1999).

Setting aside the ethical issue, the presupposition that an object *possesses* 'an intrinsic nature' which may or may not be 'altered' definitively illustrates the kind of duality inscribed in the understanding of time as separate from the things it contains. The consequence - that objects appear to be non-temporal and self-existing - is explicitly articulated in the AICCM code of ethics in which preservation is defined as 'All actions taken to retard deterioration . . . in order to maintain an object in *an unchanging state*' (1986, p. 6, my emphasis). Until recently the UKIC code similarly stated that 'Conservation is the means by which the *true nature of the object* is preserved' (my emphasis)[4].

Nevertheless, while it is relatively straightforward to demonstrate how conservation subscribes to what Loy describes as the fallacy of 'non-temporal', 'self-existing objects', it remains doubtful whether the same can be said of artists working with concepts of impermanence. Such individuals are likely to insist that it is precisely the *non-temporality* of objects which their artworks and practices set out to question. However, returning to Buren's article cited earlier; it is clear that the understanding ofephemerality advanced by these strategies is equally determined by the kind of dualistic interpretation of time under discussion. If, as Buren claims, impermanence is a consequence of the way in which time wastes things away thus making 'the effects of time' visible upon the art object, and that 'the work is always limited *in* time' (my emphasis), the art object, therefore, is not perceived as something which is *inherently* temporal (1973 p.38). Time and object is not one and the same thing, rather the object is designated as impermanent because of the recognition that time independently *acts upon* its material constitution. This, in turn, is dependent on the idea that matter is accepted as 'independent, self-existing stuff' - despite the fact that the 'self-existing' materials selected for ephemeral art are considered to be more susceptible, more vulnerable to 'the effects of time' - giving further credence to the argument that time is perceived as a container, separate from that which it contains (Loy, 1988 p. 74).

Thus, on the one hand we are presented with a substantial and objectified comprehension of time, and on the other hand, a substantial and objectified comprehension of the object, co-existing like parallel lines. On this basis therefore, it is utterly irrelevant whether one's ideological orientation lies towards permanence, as in the case of the conservation profession, or towards impermanence, as with the artist's examined so far, since both conceive time as an external force which either subjects the self-existing art object to a short, sharp shock or to an elongated process of deterioration, depending on a combination of perspective, intention, materiality, and intervention (or lack thereof).

[4]The liberal end of the spectrum of conservation theory is beginning to question these concepts. See Clavir (2002) and (1998), and Viñas (2002). The most recent UKIC Code of Ethics, published in 2004 has dropped any reference to the 'true nature' of cultural property.

From this flows a linear and durational understanding of time, whereby time as calculation is the measure of the gap between extinction and non-extinction; a gap the museum is at pains to conceal. As Temkin states: 'In a museum, it often seems, we are dedicated to preserving something larger than individual works of art; we are dedicated to preserving the fiction that works of art are fixed and immortal' (1999 p. 50). By contrast, through a spurious notion of *process*, the kinds of ephemeral art encountered so far emphasise the interval between these points, monitoring and recording motion and change in order to illuminate the before and after-effects of time's quantifiable passage.

The Divided Self in Aristotelian Time

The third manifestation of duality; the bifurcation of subject and object reinforces the container aspect of Aristotle's theory and renders the experiencing self (subject) distinct from time (object). This form of dualism results therefore, not only in the objectification of time but also in the perception of subjectivity as yet another discrete, self-existent and non-temporal "thing", engendering a delusive construction of the self. As Loy states:

> The first reified "object", and the most important thing to be
> hypostatized as non-temporal, is the I, the sense of self as
> something permanent and unchanging. So the "objectification"
> of time is also the "subjectification" of self (1988 p. 219-220).

Furthermore, the bifurcation of self and time negatively influences how the present is experienced. Loy argues that:

> Instead of past and future being understood as a function of
> present memories and expectations, the present becomes
> reduced to a single moment within a "time-stream" understood
> to exist "out-there" - a container, as it were, like space, within
> which things exist and events occur (1988 p. 219-220).

Understood in these terms, the present becomes devalued such that life is never fully lived in the moment. He goes on to observe that one consequence of this particular subject/object duality is that time appears to disappear:

> Time "flies away" when we experience it dualistically, with
> the sense of a self that is outside and looking at it. Then time
> becomes something that I have (or don't have), objectified and
> quantified into a succession of "now-moments" that cannot be
> held but incessantly fall away (1988 p. 221).

One example of the objectification of time Loy references above can be seen in the museum's decision to show Leonard's work at regular intervals and simultaneously reinforces Aristotle's notion that time wastes things

away. With each display, the audience is invited to make a mental note of how much time has *gone* by: 'Look how much *more* has been lost *now*'. Moreover, in this scenario, audiences function as the *constant* factor; the permanent backdrop against which to measure this change. Thus, by casting an audience as observers of "something *happening over there* to something which is *distinct from you*", the separation of subject and object is complete. As such, the falling away of time is embodied in the actualisation of this sort of ephemeral art work *and* in its documentation. Both, as Loy notes, depend on a dualistic experience of time. Linear sequences of photographs serve to visualise the succession of now-moments and arguably function as a lame attempt to possess that which 'cannot be held', in addition to embodying the Aristotelian perception of time as a form of quantification.

The museum also validates this dualistic conception of time, regardless of the fact that, as noted previously, the *modus operandum* of the former explicitly capitalises on and exploits the idea that time 'flies away', *accepting* the slippage or passing away of time as, in Savage's terms, 'inevitable'. By contrast, the museum through conservation is intent on retarding and suppressing time's incessant passage. Time is something which the institution lacks, for as time 'flies away' so it is perceived to systematically destroy the cultural property it contains: a concept encapsulated by Ward's (1986) book title, *The Nature of Conservation: A Race Against Time*.

Ironically, Loy's description of a subject experiencing itself as separate from time whilst simultaneously observing that separation, seems to vindicate Fried's criticism that 'theatrical' art based on a durational temporality, i.e., of time that "flies away", 'makes him [the audience] a subject – and establishes the experience itself as something like that of an object, or rather, of objecthood', quoted earlier. Undeniably there is a significant aspect of "theatre" to much of the art under discussion. Taking Gallaccio's practice as one example, the artist herself describes her installations as 'theatrical work'[5]. This is endorsed by Rugoff's statement which explicitly draws attention to the manner in which she 'has extended the theatricality of Minimalism' (1999 p. 14).

Such "theatricality" demonstrates quite acutely Loy's 'sense of a self that is outside [time] and looking at it'. Overall the relationship demanded of the audience by this kind of ephemeral art is primarily that of a spectator (subject), *observing* the durational process of time (object) wasting away the other material objects it contains. There is little which is interactive or participatory about these pieces to suggest any possibility of transcending that divide. On this issue then, Fried may well have a

[5]Lecture by the artist at Camberwell College of Arts, London, 9th December 2003.

point, although his own philosophy of time is equally inadequate since, like the museum it also presupposes a dualistic perspective.

In sum, a certain construction of ephemerality as characterised by the *Dissolution, Dispersal and Decay* strategies, in tandem with the museum, perpetuate a dualistic understanding of time. In this narrative permanence, represented as a kind of eternalism, and impermanence, its polar opposite defined in terms of absence or a nihilistic nothingness, are designated as absolute concepts, each determined by a perception of time as a continuous, durational, persisting and substantial phenomenon.

Dependent on this notion of durational time is the idea that impermanence is a measure of the temporary interval that occurs between life and death. In its capacity to waste things away, time causes the deterioration, decay and destruction of the things it contains, eventually procuring their annihilation. Conceived in these terms, time is understood to function as a container; separate from the objects within it, including the self. Consequently, Loy argues, the objectification and commodification of time itself 'convert[s] everything into a marketable resource valued according to their exchange value' such that things/objects are necessarily envisioned as substantial, self-existing entities too, occupying a particular and limited duration between two restricted temporal points on a linearscale (2001 p.274). Therefore, despite the fact that ephemeral art has traditionally grappled with the commodification of *things* and has indeed refrained from producing what might be thought of as conventional objects, arguably the artworks referenced here have nevertheless failed to challenge either the commodification of time or the commodification of the object. Ephemeral art may well have attempted to usurp the 'exchange value' by making the object physically disappear, however, by reacting within the same dualistic temporal frame of reference, the concept of durational time itself remains intact. Simply making a virtue out of reducing the commercial value of art by diminishing its durability fails to transcend the duality of time/object and time/self. As such, both the artwork (albeit a disappearing one), *and* time still retain their identity as *commodities* in the sense that both are objectified. Time remains a force, separate from and acting upon a discrete object, regardless of any reduction in market value.

Moreover, in failing to problematise the very concept of "objectness", this kind of ephemeral art *ipso facto* invariably colludes with the institutional supposition that *value* is inextricably linked with the form of a self-existing, substantial object, and that history and learning can only be transmitted through such objects. Collecting and conservation are motivated by discriminatory principles based on; aesthetic qualities, an investment in the concept of value, and the veneration of age: 'Much of what is collected and saved is not the mundane or ugly; but the beautiful', and

'Attributes such as age, rarity, beauty, cost and associations with famous people and places can make an object valuable' (Caple, 2000 pp16-17). Because the illusory understanding that things occupy a durational time-span of differing lengths and have a circumscribed life and death in time is shared equally by ephemeral art and the museum (through preservation), ultimately all these strategies really accomplish is a negative comment on this state of affairs. Instead of raising deeper philosophical questions pertaining to the nature of value, beauty and knowledge, ephemeral art is ensnared in a trap of its own making, destined to be nothing more than a defiant protest.

By the same token, these strategies fail to problematise the equally dubious status of the substantial *subject* to which the museum invariably falls prey: the collector/creator separate from the collected/created, further reinforced by an audience cast as witness to a linear temporal passage – detached observers watching something happening *out there* to *something else*, separated from the substantial object on display. Again, in this analysis, time remains an external, quantifiable and objectified substance which ultimately ensures the decay and destruction of all it contains. Such an approach fails to overcome the bifurcation of subject and object in time, because, dependent upon the notion of a self-existing object is a concept of the self as a similarly separate, isolated and contained unit. Perceiving itself as merely another object, the self identifies time as an external force whose linear passage flows in a sequential and irreversible direction. As such the present exists as a 'now-point' rather like luggage on a never ending conveyor belt, glimpsed for a second passing in front of the eyes and therefore 'is not grasped as something meaningful in itself, but as something significant only as a means to arrive at the end projected in the future' (Abe, 1992 p. 31).

Conclusion

I began with the conjecture that ephemeral art, rather than being simply another discrete stylistic phenomenon, more significantly constitutes a philosophical statement concerning the nature of time and how it functions. However, despite the fact that a dedicated critique of the ideology of the museum and art institutional system is a common impetus of artists working with the ephemeral, in fact, the understanding of time advanced by this type of work severely damages its critical potential. In essence it is merely the inverse expression of the same understanding of time advocated by the institution itself. Importantly, it is intrinsically deficient because it is dualistic. Such complicity renders ephemeral art both philosophically corrupt and politically impotent. The question this essay raises therefore is whether contemporary ephemeral art and a dualistic notion of time are *necessarily* synonymous. Is this the *only* interpretation of impermanence found within ephemeral art? Does the fact that this restricted and flawed

flawed model has come to dominate critical consciousness, mean that ephemeral art is inevitably determined by a dualistic temporal perspective or, in a different manifestation, might ephemeral art articulate a non-dualistic understanding of time and thereby function as a successful critique of the art institutional system?

Bibliography

Abe, M. (1992) *A Study of Dōgen: His Philosophy and Religion*. Albany, New York: State University of New York.

Alberro, A. & Norvell, P. eds. (2001) *Recording Conceptual Art: Early Interviews with Barry, Huebler, Kaltenbach, LeWitt, Morris, Oppeheim, Seiglaub, Smithson, Weiner by Patricia Norwell*. Berkeley, Los Angeles & London: University of California Press.

Australian Institute for the Conservation of Cultural Material. (1986) *Code of Ethics and Guidance for Conservation Practice*. Canberra: AICCM.

Brentano, R. (1994) *Outside the Frame: Performance, Art, and Life*. In: Cleveland Centre for Contemporary Art. Outside the Frame: Performance and the Object. Ohio: Cleveland Centre for Contemporary Art.

Brockelman, T. (1993) *Modernism and Theatricality*. Art Criticism, vol.8 (1) pp.49-69.

Buren, D. (1973) *Function of the Museum*. Artforum, September, p.38.

Burton, S. (1969) *Time on Their Hands*. Art News, Summer, pp.40-44.

Buskirk, M. (2003) *The Contingent Object of Contemporary Art*. London: MIT Press. Canadian Association for Conservation of Cultural Property & Canadian Association of Professional Conservators. (2000) Code of Ethics and Guidelines for Practice. Ottawa: CAC & CAPC.

Caple, C. (2000) *Conservation Skills: Judgement, Method and Decision Making*. London: Routledge.

Chapman, J. & Falconer, D. (1994) *Anya Gallaccio*. Frieze, No.15, March/April, pp.53-54.

Clavir, M. (2002) *Preserving What is Valued: Museums, Conservation and First Nations*. Vancouver, Toronto: UBC Press.

Clavir, M. (1998) *The Social and Historic Construction of Professional Values in Conservation*. Studies in Conservation, vol.43, pp.1-8.

Corzo, M. A. ed. (1999) *Mortality Immortality? The Legacy of 20th-Century Art*. Los Angeles: The Getty Conservation Institute.

Dufour, G. (1991) *Replenishing a Void*. In: Weiner Secession. Erwin Wurm: Weiner Zimmer. Vienna: Wiener Secession, pp.33-35.

European Confederation of Conservator-Restorers' Organisations. (2002) *ECCO Professional Guidelines*. Brussels: ECCO.

Fer, B. (2000) *Some transcluscent substance, or the trouble with time*. In: Bailey-Gill, C. ed. Time and the Image. Manchester: Manchester University Press. pp.69-78.

Foster, H. (1986) *The Crux of Minimalism*. In: Singerman, H. ed. Individuals: A Selected History of Contemporary Art 1945-1986. New York: Abbeville Press. pp.162-183.

Fried, M. (1967) *Art and Objecthood. Artforum,* Summer, pp.12-23.

Fung, L. (2005) *The Snow Show.* London: Thames & Hudson.

Godfrey, T. (1998) *Conceptual Art.* London: Phaidon.

Goldstein, A. & Rorimer, A. (1995) *Artists in the Exhibition.* In: Goldstein, A. & Rorimer, A. eds. Reconsidering the Object of Art: 1965-1975. Massachusetts & London: MIT Press. pp.41-227.

Harrison, H. & Wood, P. (1993) *Modernity & Modernism Reconsidered.* In: Franscina, F., Harris, J., Harrison, C. & Wood, P. Modernism in dispute: Art Since the Forties. New Haven & London: Yale University Press, pp170-256.

Horlock, M. (2002) *The Story so Far.* In: Gallaccio, A. Beat. London: Tate. pp. 11-17.

Hummelen, I. & Sillé, D. eds. (1999) *Modern Art: Who Cares?* Amsterdam: Foundation for the Conservation of Modern Art and the Netherlands Institute for Cultural Heritage.

International Council of Museums (2001) *Code of Professional Ethics.* Barcelona: ICOM.

Kastner, J. ed. (1998) *Land and Environmental Art.* New York & London: Phaidon.

Kwon, M. (2000) *One Place After Another: Notes on Site Specificity.* In: Suderburg, E. ed. Space, Site, Intervention: Situating Installation Art. Minneapolis & London: University of Minnesota Press.

Le Va, B. (1971) *Discussions with Barry Le Va. Avalanche,* No. 3, Autumn, pp. 62-75.

Loy, D. R. (2001) *Saving Time: A Buddhist Perspective on the End.* In: May, J. & Thrift, N. eds. Timespace: Geographies of Temporality. London & New York: Routledge. pp. 262-280.

McEvilley, T. (1992) *The Rightness of Wrongness: Modernism and its Alter Ego in te Work of Dennis Oppenheim.* In: Heiss, A. Dennis Oppenheim – Selected Works 1967-1990. New York: Institute for Contemporary Art & P.S.1 Museum in association with Harry N.Abrams, Inc. pp.7-76.

Messer, T. M. (1969) *Impossible Art –Why It Is.* Art in America, May/June, pp.30-32.

Meyer, J. (2000) *The Writing of "Art and Objecthood".* In: Beaulieu, J., Roberts, M. & Ross, T. eds. Refracting Vision: Essays on the Writings of Michael Fried. Sydney: Power Publications. pp. 61-96.

Meyer, U. (1969) *De-Objectification of the Object.* Arts Magazine, vol. 43 (8), Summer, pp.20-22.

Meyers, R. (2003) *Ice-as-Ice Is Art-as-Art.* In: Lewallen, C, M. ed. Everything Matters: Paul Kos, a Retrospective. Berkeley: University of California, Berkeley Art Museum & Pacific Film Archive. pp.91-107.

Michelson, A. (1969) *Robert Morris: An Aesthetics of Transgression.* In: Corcoran Gallery. Robert Morris. Washington: Corcoran Gallery. pp. 7-75.

Osborne, P. ed. (2002) *Conceptual Art.* London & New York: Phaidon.

Piper, A. (1999) *On Conceptual Art.* In: Alberro, A. & Stimson, B. Conceptual Art: A Critical Anthology. Massachusetts & London: MIT Press. pp. 424-425.

Reiss, J.H. (1999) *From Margin to Centre: The Spaces of Installation Art.* Cambridge & London: MIT Press.

Reitmaier, H. (2002) *Less Apparent.* In: Gallaccio, A. Beat. London: Tate. pp. 37-44.

Rorimer, A. (2001) *New Art in the 60s and 70s: Redefining Reality.* London: Thames & Hudson.

Rugoff, R. (1999) *Leap of Faith.* In: Gallaccio, A. Chasing Rainbows. Glasgow & Newcastle-upon-Tyne: Tramway & Locus +. pp. 7-16.

Savage. (2000a). *Interview with the artist at his home.* Bristol, 22 June.

Savage. (2000b). *Interview with the artist at his home.* Bristol, 21 December.

Schama, S. (2002) *Roots.* In: Gallaccio, A. Beat. London: Tate. pp. 21-23.

Singleton, D. (2002). *Interview with David Singleton, Registration & Assessment Officer, Conservation Department.* Bristol City Museum & Art Gallery, 21 December.

Smithson, R. (1968) *A Sedimentation of the Mind: Earth Projects.* Artforum, September, pp.44-50.

Smithson, R. (1967) *Letters. Artforum,* October, p.4.

Stambaugh, J. (1990) *Impermanence is Buddha-nature: Dōgen's Understanding of Temporality.* Honolulu: University of Hawaii Press.

Stancliffe, S. (2002). *Interview with Sandra Stancliffe, Education Officer.* Bristol City Museum & Art Gallery, 21 December.

Tarsia, A. (2000) *Time and the Immaterial.* In: Phillpot, C & Tarsia, A. Live in Your Head: Concept and Experiment in Britain 1965-1975. London: The Whitechapel Art Gallery. pp. 17-23.

Temkin, A. (1999) *Strange Fruit.* In: Corzo, M. A. ed. Mortality Immortality? The Legacy of 20th-Century Art. Los Angeles: The Getty Conservation Institute. pp. 45-50.

United Kingdom Institution for Conservation of Historic and Artistic Works. (1996) *Code of Ethics and Rules of Practice.* London: UKIC.

Viñas, S. M. (2002) *Contemporary Theory of Conservation.* Reviews in Conservation, No.3, pp.25-34.

Ward, P. (1986) *The Nature of Conservation: A Race Against Time.* Los Angeles: The Getty Conservation Institute.

Wäspe, R. (1996) *Playing Pinball: Erwin Wurm's Concept of Sculpture.* Parkett, No.46, pp.6-16.

Watney, S. (2003) *Loss is More: the work of Anya Gallaccio.* In: Anya Gallaccio. Birmingham: Ikon. pp.4-12.

Winzen, M. (1998) *Collecting – so normal, so paradoxical.* In: Schaffner, I. & Winzen, M. eds. Deep Storage: Collecting, Storage and Archiving in Art. Munich & New York: Prestel. pp. 22-31.

Wood, P. (2002) *Conceptual Art.* London: Tate.

MARION'S DEATH DRIVE:
Psycho driving and the car

Jane Madsen

Death has been associated with the motor car since the very moment of its development and in film and art similarly the car has exercised a mordant presence. Eherenberg wrote an account of the first fatal car accident in the opening chapter of his 1929 chronicle *The Life of the Automobile*, he goes on to suggest that the automobile is modernity's nemesis. By the post war period, the car, and the consequences of driving, had been embedded into culture, particularly in America. During the 1950s this had been dramatically seen in the fatal accidents of Hollywood stars James Dean and Jayne Mansfield. Hitchcock's 1960 film *Psycho* explores the mobility of modern America as a key theme. Modernity becomes the basis of the downfall of both Marion Crane and Norman Bates. In *Psycho* while the central character does not die in an accident, it is the car that facilitates the events that lead her to her killer.

Psycho is the second film in a group of films that Hitchcock made dealing with a deviant or criminal woman, the others were *Vertigo* 1958, *The Birds* 1963 and *Marnie* 1964. In *Psycho* the central woman character, Marion

Crane is a desperate woman who is having an illicit affair; a chance event occurs at her job in an estate agents and she steals $40,000. In the previous film, *Vertigo* the woman character Madeleine is an accomplice to murder, and is involved in an elaborate deception duping the character Scottie into thinking he has witnessed a suicide. In *The Birds* the woman, Melanie Daniels, is not so much criminal as foolhardy and headstrong, however when she sets out on a chase of the central male character, Mitch, it precipitates the strange and unnatural events of the massed birds attacking the town. In the last of the four films, *Marnie*, the eponymous character is a thief and an embezzler.

Hitchcock, in general, and *Psycho* in particular, has elicited a great deal of writing and research especially in the field of structural analysis and Lacanian psychoanalytical theory. This area of analysis took off with the publication of Laura Mulvey's 'Visual Pleasure and Narrative Cinema' in 1975[1], and psychoanalysis still remains a very large field of interest amongst film scholars. In many ways these psychoanalytical studies have tended to be vertical slices of certain scenes, for example, the meeting and conversation between Marion Crane and Norman Bates at the motel, the shower scene, and the relationship between Norman Bates and his mother. In her book *Men, Women and Chainsaws*[2] Clover suggests that *Psycho* is the paradigmatic first film in the genre of slasher / body horror. Hitchcock had already demonstrated in his 1945 film, *Spellbound*, that he had an interest in, and an understanding of, Freud's ideas, and this overt reference may have invited psychoanalytical studies of his films, though there has been little actual investigation into Hitchcock's knowledge of Freud. While these psychoanalytical readings of Hitchcock have produced a significant body of research, it has seemed as though there has been an assumption that this is the only way to consider his work ignoring other possible interpretations.

I. Time Space Car

The timeline and chain of events in *Psycho* is carefully laid out. The film opens with a high angle shot of buildings, a main street with cars, through to the flat terrain of the desert and mountains beyond. Even though the greater part of each film Hitchcock made was in studios and sets, the location shots were never an incidental, the landscapes were an integral aspect of the plot and the themes explored. Over the opening sequence titles of place and time are particularly noted: 'Phoenix, Arizona. Friday, December, the Eleventh. Two forty-three p.m.' The camera zooms into the upper floor of a cheap hotel room where Marion has had a lunch time assignation with her lover, Sam. The hotel is reminiscent of the interiors of Edward Hopper's paintings of lonely women in cheap hotel rooms. It is a long distance affair and Sam must leave for the airport. They cannot afford to marry as he is supporting his ex-wife; she is tired

and ashamed of the furtive meetings. Marion returns to work late from lunch, arriving just before her employer, Mr Lowrey and his rich client, Mr Cassidy, enter. A sale has been made and Mr Cassidy brags and flirts with Marion, whilst waving a wad of cash. Marion is entrusted to bank the money on her way home, she is leaving early because she says she is feeling ill, but is then shown at home in her underwear, packing a case and still has the money. The next scene shows Marion in her car pulled up at traffic lights, pedestrians pass her windscreen, the interior space of the car allows her to have a conversation in her head with Sam about driving 'up' to see him, though beyond imagining his surprise at seeing her, she doesn't really any have any kind of plan, or sense of the future. These thoughts are cut off when one of the pedestrians is Mr Lowery, who turns, recognises her and gives an inquiring look.

The majority of time that the character of Marion is on screen she is either in or with her car. She is only in the film for the first third and was an addition by Hitchcock to the original Robert Bloch novel which started at the Bates Motel. For Marion the car is her means of fleeing, in *Vertigo* Madeline's meandering drives around San Francisco become part of the elaborate deception of Scottie and in *The Birds* the car is Melanie's means to reach the seaside town in pursuit of, and to play a joke on, the desirable Mitch. However, the sexually repressed thief, Marnie, does not drive and her only pleasure is riding her horse. By the time *Psycho* was made driving had become part of the everyday, and the car in the film appears to be an inconsequential element, quite literally a means to an end. The time line of Marion's journey becomes the measure of the distance she has covered - she leaves Phoenix on Friday afternoon, drives through the night, sleeps for a while in her car, crosses the border into California, exchanges her car and continues her drive through to the next night, Saturday, when she arrives at Bates Motel, which turns out to be only 15 miles from her destination. By this time she has been travelling for some time more than 24 hours.

The choice of Phoenix as the starting point for her journey effectively emphasises and locates the space of the film in the flat empty, under-populated, desert, and once she has left the town she could be 'any space whatever[3]. The named marker of place, Phoenix, is left behind and the place she is meant to be heading towards, later mentioned as Fairvale, is fictional. The landscape of the road that she drives along, takes on elements of Auge's ideas about 'non-place'. Though Auge suggests that the conditions of 'non-place' occur in 'super-modernity'[4] he suggests that 'the traveller's space may thus be the archetype of *non-place*[5]'. Auge cites the contemporary motorway as 'non-place'[6]. Equally, in Psycho the remote highway of 1950s America in a desert, is a place without discernable landmarks, an abstracted landscape, that arguably operates as 'non-place'. Auge, further states,

> *Clearly the word 'non-place' designates two complementary but*
> *distinct realities: spaces formed in relation to certain ends*
> *(transport, transit, commerce, leisure), and the relations that*
> *individuals have with these spaces[7].*

In Psycho the 'relation' that Marion has with the highway is through time. This journey does not describe the place in which it unfolds, but rather the time or duration of the journey.

During her long drive, time and space are marked out in the nighttime by white headlight after headlight flashing past in the daytime in the rows of telegraph poles strung together on the side of the road. The flat plane of the desert is intermediate time. Marion's time with the car could be seen from the point of view of Deleuze and Guattari as,

> *'It is no longer time that exists between two instants; it is the*
> *event that is a meanwhile: the meanwhile is not part of*
> *the eternal, but neither is it part of time - it belongs to*
> *becoming. The meanwhile, the event is always a dead time; it is*
> *there where nothing takes place, an infinite awaiting that is*
> *already infinitely past, awaiting and reserve. This dead time does*
> *not come after what happens; it coexists with the instant or*
> *time of the accident, but as the immensity of the empty time in*
> *which we see it as still to come and as having already happened.'[8]*

The drive for Marion is thus both the idea of becoming as well as both the space of what has happened and the empty and arbitrary future-time of what is 'still to come'. The drive can be seen as an event existing in dead time in the desert and has a quality of becoming, but this does not imply conclusion, it is rather a space of departure and not arrival. The 'meanwhile' of the journey is also duration, or even enduration.

During her journey Marion drives without any apparent pleasure either in driving or the landscape. Virilio notes with reference to the act of driving that,

> *'With the help of the steering wheel and the accelerator pedal,*
> *the author-composer of the trip will in effect arrange a series*
> *of speed pictures, which will playfully sneak up on the*
> *transparent screen of the windshield.'[9]*

In *Psycho* driving is the model for the unorthodox narrative structure of progressive forward linear movement that never turns back. Borden states with reference to the motorway, but equally applicable to a highway in a desert, that,

> *'...motorway driving perhaps more than any other driving,*
> *produces a kind of cinematic view through the windscreen, a*
> *place where high speeds mean that foregrounds are blurred*
> *and the distant view is privileged.'[10]*

It is inviting to see the windscreen as a parallel for the cinema screen, and the tropes of cinema such as montage, tracking shots, pans and so on, but that is the film in the car, whereas, the car in the film does not always do this.

In *Psycho* Hitchcock eschews the opportunity to represent pano-ramic, widescreen images of the desert through the windscreen from the drivers point of view, preferring to show Marion at the wheel. The shots through the car establish the interior space; mostly these are through the windscreen when she is driving. Further, Hitchcock, does not bother with being in the location very often. The images of the Arizona highway and the desert are shown back projected through the back window of the car. The emphasis on looking backwards through the car creates a number of possibilities for interpretation. By primarily, looking backwards it shows what has already been, what she is leaving behind, as she flees with the $40,000, and the constant looking back dramatises her guilty escape. It was noted by Hichcock's biographer that 'the characteristic subject of his art, often taken to be suspense, is more accurately anxi-ety' and that because of his own fears of authority figures, especially the police he rarely drove a car when he went to live in America[11]. The music used over Marion's drive, the same over the opening credits, enhances the sense of flight and her anxiety that she might get caught.

There is a different view through the car in the scene after she has driven through the night, the film cuts to morning and her car parked on the side of the road. A police car pulls over and the officer gets out, looks in her car and knocks on the side window waking Marion up. She is panic stricken; from the point of view of her guilt, his big face with dark sun-glasses looks threatening; she winds down the window of the driver's door and, trapped in its frame, explains she was tired from driving so slept, and challengingly, asks if she has broken any laws. It turns out he is trying to be helpful, and with unknowing irony suggests that it would be safer for her to stay in one of the many motels in the area. He becomes suspicious and asks if there is anything wrong, she replies, 'Am I acting as if there's something wrong?', the policeman answers 'Frankly, yes'. He then checks her licence, which she furtively retrieved from her handbag whilst hiding the money, and looks at her Arizona number plate, permits her to go, fol-lowing her to the next town. In a shot through the windscreen, where the expectation would be one of looking ahead, Hitchcock uses the device of the rear vision mirror centred on the screen to show Marion's point of view as she anxiously looks back at the police car. During her lonely journey Marion is trapped by the slim chance that she might escape. However, the car, the very means of her escape, in fact binds her in a simultaneous state of motion and claustrophobic confinement.

The experience of driving for long periods on dreary motorways, or here

on a desert highway can also create the time for reflection, according to Borden,

> '...motorway driving is often used as a space of contemplation
> - where the very neutrality and supposedly boring nature of
> driving is reinvigorated by thoughts and memories' [12]

In *Psycho*, the lack of pleasure is further reinforced in the lack of comfort in the car; there is no radio, no music, just the sound of the car. In her isolation on the road, her thoughts turn inwards to the possible conversation between the policeman and the salesman in the used car yard as she leaves, and to the imagined future scenario on the following Monday morning with Mr Lowery's and her colleague, Carolyn's puzzlement concerning her absence from work, the discovery of the embezzlement of the $40,000 and the indignant rage of Mr Cassidy whose money has been stolen. The conversation amongst these characters escalates in her head and compounds her guilt and anxiety. The scene is also narratively economical, Hitchcock's biographer noted that rather than cutting back to a scene in the office, Hitchcock and the screenwriter thought would be more effective to construct it as a voice-over . As an interior voice it becomes her fearful imagination, rather than action. Further, it prevents the action from going back to the office and instead, she and the narrative drive relentlessly forward. Deleuze argues that,

> Hitchcock introduces the mental image into cinema. That is he
> makes relation itself the object of an image, which is not
> merely added to the perception, action, and affection images,
> but frames and transforms them. With Hitchcock, a new kind
> of 'figures' appear which are figures of thoughts.' [14]

The shots through the windscreen have another practical outcome of allowing more shots of Marion. As the journey progresses she has time to think about her actions she becomes less certain and more guilt-ridden. By the time the second night of her journey has fallen, it has started to rain heavily, she is no longer just anxious and guilty, her mental state is demonstrated; she is shown squinting and exhausted and she is beginning to visibly disintegrate, her distorted face caught in the on coming headlights. Then she sees the sign for the Bates Motel, pulls in and within a relatively short space of time is murdered and the narrative transfers to the character of Norman Bates, and does not return to Marion or Phoenix.

II. Money Desire and the American Dream

In the late 1950s and early 1960s America cashed in on the economic expansion of the post war decade. There was so much to buy and so many things to have. The images of aspiration and acquisition effortlessly pervaded American cinema. For Hitchcock, as an outsider, and an Englishman whose father was a shopkeeper, a deep understanding of, and a willingness to depict, class is evident. However, any notion of class, is dispensed with

in the concept of the 'American dream'[15], where there is an act of faith in the idea that if one is diligent and works hard, rewards will surely follow irrespective of background or origins, or in other words, mobility. The 'American dream' emerged as a depression era idea, and in films of the pre-war period, social mobility is a recurrent theme[16]. After WWII this was represented materially in aspiring to a (bigger) house and a (bigger) car. By the time *Psycho* was made, mobility was also associated with the modernity of anonymous movement from place to place, and was emerging as an indicator of alienation.

In the four films on deviant women, money and wealth is carefully delineated throughout. In *Marnie*, Mark's banker cousin calculates the cost of his rushed wedding to Marnie as amounting to $70,000, and it eventuates that the scale of her career as a thief has netted $150,000. In her solitary movement across the country, *Marnie* has had a number of different identities; aliases are also used in *Psycho* and *Vertigo*. The cars in these films, which may seem apparently incidental details, aspects of everyday life, are used to good effect to reinforce the social status of the characters. In *Vertigo*, Scottie is duped by an old college acquaintance into to keeping check on his supposedly suicidal wife. She is from a family of shipping magnates. Scottie follows Madeleine as she meanders around San Francisco in a green Mark VIII Jaguar and he trails her in his 1956 DeSoto Fireflite. The Jaguar would be an indicator of wealth and upper class refinement, as befitting Scottie's English college friend and his wife, whereas his DeSoto, would be read as, while not the most humble of cars, more the choice of the low level manager. They travel together in the Jaguar on outing to a sequoia forest. When they drive to the Spanish mission, which ends in her supposed suicide, Scottie drives her car, this drive is paralleled in his DeSoto, when he repeats the same journey with Judy, the tawdry woman who was all along impersonating Madeleine. The car driven by the flighty, rich, socialite, Melanie Daniels, in *The Birds* is an Aston Martin DB 2 / 4, a rare English sports car from the 1950s, which on the west coast of America in the early 1960s would have demonstrated her wealth, but also would have appeared exotic and esoteric. The men in these films drive American cars, it was through the number plate of his sensible 1962 Ford Galaxie 500 that Melanie was able to trace Mitch's identity in *The Birds*; in *Marnie*, the male character, Mark drives a 1963 Lincoln Continental, seen at the time to be an elegant car of the bourgeoisie.

In *Psycho*, money is a problem for both Marion, and Norman Bates, for different reasons they have been by passed by the 'American dream', defeated by their ordinariness. Marion and her lover cannot afford to marry, and the paucity of her situation is compared later, in her office when the crass, nouveau riche, Mr Cassidy, is buying a house as a wedding present for his daughter, for whom money is clearly no obstacle. As he waves the $40,000 bundle, both Mr Lowery and Carolyn look askance, he

says to Marion, 'Do you know what I do about unhappiness? I buy it off...' She puts the money in an envelope ready for the bank, folds it awkwardly, and stows in her handbag. The very physicality of the cash makes it an object; it is foregrounded on her bed as she packs and absconds, she hides it from prying eyes of the policeman, and at the used car yard, out of sight in the ladies room, she carefully peels off $700, the difference paid on the trade in. Her actions arouse suspicion in the policeman and 'California Charlie' the used car salesman, who comment on her hasty cash purchase, whereas it was not seen to be an unusual event for a lone woman driver to sell her own car. The money continues to be an object and further, it is used to create a sense of anxiety in the audience; she tries to find a way of concealing it in the motel room, so carefully arranges it in two piles between the pages of the newspaper, it remains in view throughout the scene while Norman Bates clears up the room after she is dead and unwittingly he picks up the newspaper with the money in it, and is the last thing he tosses in the boot discarding it with the body, and finally removes the cash from circulation.

Given that the policeman follows her to the used car yard, and watches her transaction, it is unclear why she trades in her car, though during the scene she is stressed and panic stricken and wants to get away quickly. The used car yard at the side of the road in an unspecified town is flat and ordinary with is flapping bunting and closely parked cars is a site that could be anywhere, it is another 'non-place', where the buying and selling cars is part of the experience of driving. She drives a black 1956 Ford Mainline, the most basic Ford, a commonplace car used by working class people, which she arbitrarily exchanges for a light coloured 1957 Ford Fairlane 500, another unexceptional car. The different state plates marks the distance she has travelled from Arizona crossing the border into California. Despite having a lot of money she resists the temptation to trade up. In the used car yard, which only sold American cars, there were more coveted cars available. The shades of the two cars parallel the much analysed white and then black underwear of the opening scenes. Finally, the car becomes her coffin, as Norman Bates hides her body in the boot, then watches as the car slowly sinks in a bog, and the last moment of the film is of the car being dragged out. When Marion's sister and Sam investigate her disappearance, and suspicion falls on Norman Bates, it is assumed he killed her for the money, that the only thing he could want is money. For Deleuze and Guattari, this can be seen as,

> 'The deliberate creation of lack as a function of market
> economy is the art of a dominant class. This involves organizing
> wants and needs (manqué) amid an abundance of production;
> making all of desire teeter and fall victim to the great fear of
> not having one's needs satisfied; and making the object dependent
> upon a real production that is supposedly exterior to desire
> (the demands of rationality), while at the same time the production
> of desire is categorized as fantasy and nothing but fantasy.'[17]

Desire and money are equivalent and interchangeable aspects of yearning for the 'American dream'; and Marion and Norman Bates have trouble with acquiring and hanging on to both.

The failure of Marion and Norman Bates to participate in late 1950s prosperity and conformity underlies their actions. The highway has been moved away and it is the arbitrariness of the wrong turn that brings them together as victims in a collision of their thwarted relationships with modernity. They are both guilty, but are apparently acting in separate chains of criminality as a thief and a murderer, which culminates in her murder in an exchange of relations when they randomly meet. The Bates Motel is an unsuccessful enterprise, now passed by, and Norman says, '...no sense dwelling on our losses, we just keep lighting the lights and following the formalities.' The Motel is a single story building of plain cabins with ordinary interiors, and not the 'Terrible Place' that Clover sees a key element of the body horror genre, she states,

> 'What makes these houses terrible is not just their Victorian decrepitude, but the terrible families – murderous, incestuous, cannibalistic – that occupy them. So the Bates mansion enfolds the history of a mother and son locked in sick attachment...'[18]

The problem with this point is that Marion doesn't go near the mansion[19]; she is murdered in the brightly lit, pristine white bathroom with its utilitarian white tiles, white bath, white basin and white toilet, more reminiscent of an operating theatre. Later, the private detective, Mr Arbogast, is killed in the mansion and it emerges that Norman Bates has poisoned his mother and her lover there[20]. Marion's death in the shower is not a gothic slaying, but one that takes place in the location of a modern bathroom, like anybody's bathroom, almost a 'non-place'. The implication here is that by the late 1950s that old things needed to be dispensed with, and the old-fashioned mansion with its late nineteenth century interior was simultaneously fearful and obsolete. Hitchcock is sceptical about this drive to modernise, and he makes it is clear that there is no predictable or specific location for terrible things to happen.

Conclusion

The psychoanalytical and structural analyses of *Psycho* have focussed lavish attention on deconstructing the latter, gothic denouement of the film, where Marion's murder is seen to have a causal dimension, and is interpreted as punishment for her illicit sexuality, rather than her actions as a thief, and Norman Bates Oedipal relationship to his mother makes his desire for Marion transgressive and deadly. Yet, *Psycho* is a hybrid of the old and the new. It is through the representative elements of the new in the material gains of the 1950s and 1960s that Hitchcock explores ideas about social mobility and aspiration against America's uncertain and

uneasy relationship to class in *Vertigo, Psycho, The Birds* and *Marnie*. Alternative readings of Hitchcock can be proposed through considering the dynamics of material wealth and consumption such as those represented in driving, cars and criminality in these four films. In Psycho the characters desperate attempts to stake a claim to a share in the 'American dream' exposes the limits of modernity. Hitchcock offers a critique of the desire for affluence and mobility in *Verigo, Psycho, The Birds* and Marnie. In Psycho, Marion Crane's solitary interstate getaway through the 'non-place' of the desert highway traps her in the claustrophobic interior of the car and in the vacuity of aspiration that proves fatal.

Notes

[1]Written in 1973 and published in Screen 1975, this essay is perhaps the most quoted and referenced essay in the study of cinema. See Mulvey, L. Visual and Other Pleasures London Macmillan 1989

[2]Carol Clover Men, women and Chainsaws' London BFI 1993. Clover's central thesis is a challenge to the idea of the (male) gendered gaze, originally set down by Laura Mulvey, though still within the field of psychoanalytical theory. In order to establish her thesis, Clover sometimes glosses over details.

[3]Deleuze, G. Cinema 2 London Athlone Press 1992 preface

[4]Auge, M. Non-Places London Verso p93

[5]Auge ibid p86

[6]Auge ibid pp97-8

7Auge ibid p94

[8]Deleuze, G. and Guattari, F. What is Philisophy? London Verso 1994 p158

[9]Virilio, P. 'Dromoscopy, or The Ecstasy of Enormities 1' Wide Angle 20.3 (1998) pp11-22. p12

[10]Borden, Iain 'Drive: Urban Experince and the Automobile' in www .haeceeityinc.com p17

[11]Taylor, John Russel Hitch London Abacus 1981 p9

[12]Borden O. Cit. p18

[13]John Russel Taylor Op. Cit. p234

[14]Deleuze, G. Cinema 1 London Athlone Press 1992 p203

[15]the term is generally accepted as being coined by James Truslow Adams in The Epic of America 1931.

[16]see Elsasser in Donald Richie Fantasy and the Cinema 'Social Mobility and the Fantastic: German Silent Cinema' pp25-29

[17]Deleuze, G & Guattari, F. Anti Oedipus Minneapolis Univ Minnesota Press p28

[18]Clover Op. Cit. p30

[19]the Bates mansion is based on Hoppper's painting 'House by the Railroad' 1925

[20]Clover p 35, mistakenly claims that in Norman Bates sexual psychosis, only female victims will do.

Art as a process of delimitation: Essentialist and Non-essentialist approaches

Nina Arnth-Jensen Rodin

In order to see that basket, said Stephen, your mind first of all separates the basket from the rest of the visible universe which is not the basket. The first phase of apprehension is a bounding line drawn about the object to be apprehended. An aesthetic image is presented to us either in space or in time. What is audible is presented in time, what is visible is presented in space. But, temporal or spatial, the aesthetic image is first luminously apprehended as self-bounded and self-contained upon the immeasurable background of space or time which is not it.
James Joyce, A portrait of the Artist as a Young Man (2001, p.164)

Even if artists enjoy more freedom than ever as to forms of expression available to them, they may still wonder about the nature of their endeavour and perhaps most so when an uncomprehending public exclaim "Surely, this is not art?!!". My reply is often: "You may not like it, but yes, it's art." But what grounds this judgement? And how, with only a strong intuitive conviction can we defend a pluralistic mode of artistic expression against what feels like intolerant value judgements.

There is a broad consensus, established in the 1950s that art cannot be defined and that there is no need to pursue an essentialist definition: artists and critics get along without and we have to take art theories and artworks on a case-by-case basis (Warburton, 2003; Weitz, 1956). Yet this is rather problematic not just for determining what does and does not constitute art but also because 'Unless we have an understanding of the signification of the term 'art', how can we write histories, or sociologies, or criticisms of art?' (Zerby, 1957)

Against this consensus, I will argue that there is an underlying commonality to all that we call art, at least in the activity of making art. In this essay, I first attempt to formulate a new essentialist definition of 'art' before considering Wittgenstein's notion of family resemblance, which is the theoretical basis for the rival anti-essentialist tradition (Weitz, 1956).

Something finite from the continuum of conscious experience

If I think of *when* I do art, that is the smallest common denominator at the core of artistic practice, it would appear to be a process of plucking something finite out from the continuous flow of my conscious experience. 'Art' is essentially a process of delimitation from an otherwise continuous experience of life. This notion seems to resonate through a lot of what artists do and say, as in the words of James Joyce quoted above or in the numerous examples of visual art I shall consider in this essay[1].

When we reflect on *why* artists do art, it is fundamentally so that they can take a second, closer or deeper look, perhaps to try and capture a memory, perhaps because they sense that there is something of value they want to keep or to comment on. I believe that one purpose of delimitation is to be able to re-live and potentially therefore re-examine or re-evaluate that particular part of experience.

The universal value of art is something that I believe derives from the particular condition of human consciousness, which is at once encompassing of our experience and indivisible from it. A helpful image, is that consciousness is like taking part in the movie you are trying to watch: one's consciousness cannot separate and distance itself from the action around it. It can never take the objective perspective enjoyed from a seat in the cinema. By delimiting something from our conscious experience with the option of replaying it to one-self, art affords us the illusion of being a spectator to our conscious experience. Separating ourselves from our consciousness is impossible in the strict sense, but art is the next-best option.

Similarly, Wittgenstein states: "I look in the mirror. I can see my eyes but can I see the "I" that sees them?" and also: "I and the world coincide

and yet my world is unique. I am the limit of the world, but I cannot draw a boundary round it, for to do that I would have to be able to step outside it, which I cannot do."[2]

But 'art' affords the illusion of a boundary within one's own world and the promise of stepping outside it[3]. Thus art may be seen as a coping strategy for living with a human consciousness, something that we cannot control, only record (Wegner, 2002)[4].

Proposing a new essentialist definition of art

Could a process of delimitation to deal with the continuity of our conscious experience form the basis of a definition of art? Presented as a set of necessary and sufficient conditions, an essentialist definition might be worded as follows:

> Art is a process whereby one (the artist) (1) delimits something
> finite from his continuous, conscious experience (2) in order to
> distance himself from it or for it to be revisited or re-evaluated by
> himself or others (the public) (3) rather than exclusively for
> purposes of financial gain, sustenance, the prolongation or easing
> of life, or the attainment of philosophical or scientific truth.

I have divided the definition into three parts, which I will briefly elaborate. Key to the part (1) is the idea of finitude. I avoid the term "artifact" as unacceptably restrictive to artistic practice. Instead, art can be the process of delimiting a moment in time, a thought, a sound, an action or perhaps just a particular situation. My definition does not invoke or depend on what is bounded by the delimitation (the work of art) but rather the process or the activity, through which works of art are created - a distinction, which I will return and expand on below. By 'conscious experience', I mean 'the perception of all that passes in a man's own mind' (Locke in Block et al., 1998, p.12), including also dreams, active imagination and those fleeting more passive creative 'a-ha' moments (Wegner, 2002, p.83).

Part (2) is both temporal and normative. The special value of delimiting something finite, of picking out something from the continuum, is that it can be re-evaluated later in time. This normative aspect of the definition is a virtue, because it helps to explain why we view the term art itself as normative, that is to say why we believe that describing something as a work of art is already to attribute a distinctive value to it (whatever other merits it may have). While this clause could be read as prescribing a restricted purpose to the activity that is art, it is meant to be open and all-encompassing rather than exclusive or partisan as so many other definitions and theories of art[5]. It does not prescribe that emphasis be placed on Significant Form, beauty, skilled representation or the capacity to communicate emotion[6]. These are all possible reasons for the delimitation

but neither is exclusively true: all are to do with grasping something that would otherwise be transient to our experience.

Part (3) is possibly the most problematic. It seems that without (3), then (1) and (2) taken together could equally well describe activities such as business, cooking, science and philosophy. It would be a significant flaw for the definition if it included these activities as instances of art. I return to this in the discussion of sufficiency below.

Advantages of this definition compared to previous theories of art

Before examining the formal properties of this definition, I would like to look at some advantages over previous theories of art, of which there are at least two.

The first advantage is that my definition seemingly avoids the problems of circularity whereby a definition rests on terms which themselves are logically dependent on the term to be defined (Warburton 2003, p.22-24). This is most notably the case with the Institutional Theory, the Significant Form Theory and Levinson's definition[7] where art is defined as a function of 'the art world' and 'significant form' respectively. My definition steers clear of such terms. It does depend on terms such as "conscious experi- ence" but I believe that these can be defined or at least discussed in terms that are independent of the concept of 'art' (Block et al., 1998). Instead, my definition can be said to be constructive because the defini- tions of 'artist' and of 'work of art' (two concepts which have also eluded definitions so far) are derivatives of my definition of 'art' as the agent and the product of the process, respectively.

The second advantage is that by defining art as a process, it sidesteps the difficulty of defining artworks by their physical characteristics or by the effect they exert on a public. This approach pervades most theories of art to date but is perhaps best exemplified in Richard Wollheim's book *Art and its objects* (1980) in which he argues for the indissolubility of the work of art from the physical object[8]. One problem with this position is that, even if one could find a property common to all and only artworks, 'such is the temperament of artists that the discovery of such a property would provoke a reaction against it' (Davies 1991, p.6).

The difficulty of finding necessary and sufficient physical characteristics for artworks can be further appreciated by considering the paradigms of 'driftwood art' and 'ready-mades'. Unless one excludes these from the class of 'artworks', then an essential definition has to explain how two objects can be physically identical but one be art and the other not (Danto 1983). Henry Moore had a large collection of found pieces of driftwood, bones and stones in his studio (Moore at Kew, Exhibition, 2007), difficult

to sort from some of his smaller sculptures and maquettes. Similarly, one that Duchamp did not delimit, it is art because Duchamp clearly delimited it from the rest of his experience for re-evalution. With the development of conceptual art (e.g. Warhol's Brillo Boxes, in Danto,1983), Tilghman (1973) is right to say that we would have a hard time in sorting artworks from the rest in Kennick's (1958) burning warehouse: beyond the classic examples of ready-mades and driftwood art, there is now a whole class of 'indistinguishables', objects or performances which can be hard to tell from their non-art counterparts[9]. However, with my definition, as long as we have some means to establish that the objects result from a process of delimitation by the artist (admittedly problematic in a burning warehouse), we can conclude that these objects are art.

Necessary conditions: bringing some forms of art in from the cold

One of the difficulties with an essentialist definition of art is how to test it. The best methodology is to test the theory against linguistic intuition. This is done in two parts. The first is to investigate whether the features of the definition constitute necessary conditions; that is whether each and every entity generally considered to be art complies with the conditions of the definition. Particular attention should be paid to controversial works whose status as art is ambiguous or contested. It will be considerable evidence of the success of my definition if it has the power to explain why controversial works of art indeed merit that designation.

My definition does not require the artist to delimit an object rather 'art' can be the delimitation of an experience, an event or a series of events, a performance, an idea or a situation[10].

For example, the experience of driving on the unfinished New Jersey Turnpike described by Tony Smith (Wagstaff, 1966, cited in Harrison and Wood, 2003, p.760) may qualify as art. Tony Smith had delimited the experience even before he shared it with the interviewer: the transcript is merely the evidence for a delimitation that has already taken place. But it is clearly something finite (restricted in time to the actual journey on the turnpike) which stood out from the continuum of his experience and which he delimited in his mind for further consideration. He says: "The road and much of the landscape was artificial, and yet it couldn't be called a work of art" – and this bothers him. My definition helps us solve the conundrum: while road and landscape may not be art, his delimitation of his experience of driving there is.

In the case of Martin Creed's *Work No.227: The lights going on and off* (2000), what is delimited is again not just the object (the light fittings at the Tate that were used were there and are still there) but also the fact that they were set to go on and off at 5 second intervals. The delimitation,

while not just of an object but also of a series of events, is specific andto this piece but not theoretically necessary for such a delimitation to be art[11]. I once experienced a faulty neon tube in a motorway stop which really stood out for me, gave me a very particular sensation and which I returned to before leaving. The insistent flickering was like the urgent and anxious rhythm of something about to explode, and to me felt symbolic of the precarious condition of this crowd of people eating fast food next to a congested motorway. I could have videoed it or tried to reproduce it in a gallery. But even just in my mind, it was already 'art' – I can still picture it clearly today, and have mentally been able to return to it ever since. Art, unlike language, can be purely private.

Another artist whose 'art' defies the notion of artefactuality but satisfies the condition of delimitation is Richard Long. He makes sculptures by walking: his 'art' is the activity of delimiting a particular walk. He records or describes his work with maps; photographs or text but distinguishes these physical objects from the walks, his actual work.

The 'something finite' may just be an idea: in *Christian Boltanski*, the artist tells Tamar Garb of his exchanges with a Tate curator who has bought his work *The Reserve of Dead Swiss* (1990): the curator asks if they can reprint the photos when they fade; if the shelves could be made shorter; if the cotton could be replaced when it deteriorates. To all, Boltanski agrees, leaving the curator to wonder what they have actually bought. Boltanski replies 'an idea, not an object' (Semin et al., 1997)[12].

Finally, art may be just a situation delimited by the artist. Visitors to the group show *The World as a Stage* (Tate Modern, 2007) are instructed by the staff member at the entrance to "tread lightly, leave no trace". This is art by Tino Sehgal. The work exists in no other form (no written or audiovisual record) than this interaction between Tate staff who act as 'interpreters' and visitors. This is typical of the Relational Aesthetics movement (Bourriaud, 1998) where a situation is delimited by an artist, to be experienced, lived and interacted with (and often re-delimited) by the audience, who I would argue become co-authors in the process. Perhaps computer games and role-playing games are also best understood in terms of Relational Aesthetics, as an interaction between artist and public where the process of delimitation is started by one and completed by the other.

Explaining 'Indistinguishables' and authorship: the primacy of the artist

If I see a man walking I cannot tell if he is 'doing art' unless I can establish that he is delimiting the walking from the rest of his experience with the aim of re-visiting that particular experience. Instead, the artist himself, is in a privileged position to decide what is classified as art[13]. I would include his work in the class of 'indistinguishables', works of art which are in all outward aspects impossible to tell apart from their non-art

would include his work in the class of 'indistinguishables', works of art which are in all outward aspects impossible to tell apart from their non-art not believe that they should be thought of as a lesser form of art (Davies, 1991, on the artefactuality condition p.138).

At Frieze 2007, Richard Prince's *Untitled* (2007) looks indistinguishable from a scene at a car fair: a 1970 Dodge Challenger slowly rotating on a platform and being caressed by a woman in a pink bra and hotpants. But this is not just a classic ready-made: Prince states that the car ceases to be art when it is driven out of the gallery (Pilkington, 2007, p.5). If one tries to define art by the physical characteristics of the object, this would be an unsolvable conundrum. Seen from the perspective of delimitation, however, it seems clear that the artist's delimitation includes both the ready-made and the time and place. In this case the gallery is not just what validates the ready-made (as stated in the Institutional theory[14]) but an integral part of the artwork.

In the series of work *Liebe Maler, Male mir*, Kippenberger hired poster-painters to execute his paintings from photographs. On the subject, Kippenberger, states: "I am not an easel-kisser, I have nothing to do with painted pictures, that's why one of my solutions for this problem has been to let others paint for me, but only in the way I need it, the way I see it"[15]. The painting is done by others; the delimitation is his, as is the claim to authorship[16].

Explaining the universality of art: anthropological art

Next, I want to consider examples that illustrate the universality of art and how this process of delimitation can be applied to what is often referred to as anthropological art. The cave painting of the San people are possibly the oldest (up to 77,000 years old) form of paintings for which first-hand accounts of their meaning survives[17]: they were the sacred records and embodiment of visions experienced during ritual trance-inducing dances, which were thought to be journeys into the world of the gods, central to the San system of thought. Irrespective of whether the San had a concept such as 'art', I think that today we can classify the cave paintings as art because they were clearly meant to delimit important specific conscious experiences and were revered as a mode of re-visiting these. I would contend that a lot of sacred art, and representations of Gods, have the specific function that they allow the artists to repeatedly revisit and reconsider their relationship and attitude to these Gods and that a lot can be understood by studying what is included or excluded from the particular delimitation that is religious art[18].

Explaining the creative process

The idea that delimitation includes some things as much as it excludes

others is very much embodied in the re-iterative process by which a lot emotion), which I try to delimit (or isolate) from the flow of conscious-ness. In doing so I am implicitly re-evaluating this first interpretation of the original experience (against perhaps the memory of what I was trying to delimit) but now modified by my present experience. This re-visiting is thus invariably a new experience in itself, which often prompts me to reform the first delimitation[19]. Both rational decision and subconscious thought will influence what I include and what I leave out. A work may be completed when the delimitation best suits the part of my conscious experience that I first wanted to delimit but it may also evolve into delimiting a subsequent conscious experience, which I am more interested in re-visiting than the initial one. Accident can play a role in the delimitation but only if it is an accident I wish to re-visit.

Imagine a person goes to the greengrocer, buys a lemon, takes it home and puts it in my fruit-basket. Is it art? Here, I believe all depends on the motive for placing the lemon. If it is simply that this lemon stood out from his conscious experience and is specifically delimited for re-appraisal, (for example it was that lemon as opposed to all the others in the crate or he had chosen a lemon as a symbol for the bitterness that he wanted to delimit from his experience of life at the time or), then it would be art. Perhaps the fruit basket is also important for this delimitation. If on the other hand he just needed a lemon to make his dinner more palatable and the fruit basket was just a practical place to keep it, then I wouldn't want do designate his activity as art. This brings me to consider examples of delimitations that are not art.

Sufficient conditions: Excluding Nature, animals and robots as artists

The second test for the success of a proposed definition is to ask whether meeting the criteria is sufficient for being art or whether they may include other things, which are not commonly thought of as art. For example, my definition does not include nature, animals or robots as potential artists. I do not believe that a leaf is art (of which nature is the author - Wollheim, 1980; Weitz, 1956) until that leaf has been picked up and separated (delimited) from the rest by a conscious actor for the purpose of later re-consideration. Any definition that focuses only on the object will face a problem because it is always possible for an identical object to be produced in nature with no human involvement. Focusing on the (human) process avoids this difficulty. Equally a robot or an ani-mal may be very adept at creating interesting delimitations (producing endless combinations of random shapes or very expressive paintings) but unless one can show that the robot or the animal are delimiting a part of their conscious experience and are able to subsequently re-visit or re-appraise the work, it would not be 'art'. We can use either a robot or an animal to produce paintings, but it is we in the end who choose which to print and which to frame as art, to be re-considered as such.

Sufficient condition: The importance of the agent's primary motivation

When it comes to sufficient conditions, the third part of my definition is crucial. When I go for a walk, I may delimit subsets of my experience by taking photos but I am not delimiting the entire walk itself as what I want to record and revisit. Rather it keeps me fit and has the added advantage that it may prompt me to do 'art' on the way. So although some delimitation, some 'art' may happen on the way, this is not the primary intention with the walk. Similarly, lemons tend to be primarily for eating.

The notion of primary motivation is also important when considering illustration or craft. The illustrator's brief can be construed as delimiting another person's ideas into images. Unless he is also including some of his own experience (and most good illustrator-artists do) I am not sure we would call it 'art'. For example, a completely factual schematic illustration for a geometry book should not include the illustrator's own input and should not be considered art. Such scientific illustration is more like a craft: it is about knowing how to use layout programs, how to produce vector graphics, clear graphs etc. This said, crafts often have an element of art. If I hire a carpenter to make me a table, he could just make me a table top with four legs but if he were to make it (delimit it) with carvings and curves and with particular proportions that he finds meaningful and important enough to include, there would certainly be an element of art.

Science and Philosophy: artistic processes?

It is much more difficult to find a principled way of using my definition to distinguish artistic processes from scientific, philosophical or business processes. If I have an interesting business idea and I make a note of it so that I remember it, the only thing that keeps it from being art is the third part of my definition, that the primary purpose would be to re-visit the idea rather than financial gain. Similarly with philosophical or scientific ideas. When I worked as a scientist in the field of neurophysiology, new ideas would quite often feel like a rather fleeting part of my conscious experience, something I would have a strong urge to delimit and set apart from the rest, lest this inspiration should escape me. At first, the idea would just be something interesting, different, that needed to be set apart. Only later would this idea sometimes be incorporated into a process of establishing a scientific truth. For me, this more intuitive and creative part of the scientific process is very akin to art[20]. Similarly as I am now grappling with philosophical investigation, and am trying to delimit the most important part of my conscious experience, constantly re-visiting my writing to see how it matches my thoughts, I may not be doing something vastly different from someone writing a novel. The only difference is in the nature of my motivation though I find it difficult at present to

describe exactly how it would differ from that of the novelist.

One solution is to elaborate on the rather ad hoc third clause of my defini-
tion and add to it specifically to deal with any disturbing counter-examples
though this may affect its explanatory power. I find it more plausible and
persuasive, however, to admit that business, science and philosophy ideas
may originate in similar ways to artistic ideas and that the processes
behind those disciplines are actually quite art-like[21]. Still there is a danger
here that my definition is too inclusive at this stage and may not yet be
complete as an essential definition. But even if my definition possibly fails
as an essentialist definition, it may still be valuable in the context of the
rival (non-essentialist) tradition of Wittgenstein's linguistics, as applied
to art by Morris Weitz.

Wittgenstein's notion of Family Resemblance...

In his Philosophical Investigations (Anscombe and Rhees, 2001),
Wittgenstein pioneered an account of language, which attempts to explain
how words and concepts can have meaning in the absence of essentialist
definitions. Though we may state necessary and sufficient conditions of
definition for some words (e.g. a bachelor is 1. a man 2.who is not mar-
ried), others are not immediately amenable to such form of definition.
In the context of explaining what he means by the word 'language'
Wittgenstein argues that concepts can have a meaning and be used even
without (or before) the existence of essentialist definitions. He illustrates
this with the concept of a 'game' (aphorisms[22] 66 to 75)[23]. He argues that
we can tell a 'game' from something that is not without knowing even
one necessary or sufficient condition for something to be a 'game'. For
example, some games may involve winning and loosing (though this may
not be relevant to a young child kicking a ball against a wall), some are
amusing (but chess needn't be), some may be competitive (except, he
says, think of patience), etc... Cards and tennis are both games and we
know this before we can point to what they have in common, simply from
our experience of the word 'game'.

For Wittgenstein, concepts are defined instead by similarities with a set
of overlapping characteristics, akin to resemblances between members of
a family. While no one of these characteristics is sufficient to determine
membership of the family, they are like strands of fibre, which as long as
they overlap sufficiently can produce a strong thread, a meaningful mode
of definition (aphorism 67).

Such concepts are said to be logically open rather than closed (Osborne,
1973). Wittgenstein believes that new instances can always occur where
the existing strands of definition are insufficient to determine whether
an instance is covered by that concept or not and a decision has to be

made. He argues that a community of language users has to make such a with accepted existing instances. However the similarity conditions can also evolve and new conditions will need to be added while others become obsolete over time. In summary, if a number of people can reach a consensus on a sufficient number of characteristics by which a new instance resembles existing members of the family, then eventually this new instance may be accepted as part of this family.

Morris Weitz and the concept of art.

Morris Weitz argues that 'art' is just such a family resemblance concept. He believes that essentialist definitions to date are 'logically doomed to failure', because art can only be understood in terms of Wittgensteinian family resemblances (Weitz 1956; Davies 1991, Chapter 1). He does not discount attempts at essentialist definition as meaningless:

> 'If we take aesthetic theories literally [...], they all fail; but if
> we reconstrue them, in terms of their function and point, as
> serious and argued-for recommendations to concentrate on
> certain criteria of excellence in art, we shall see that aesthetic
> theory is far from worthless. Indeed [...] it teaches us what to
> look for and how to look at it in art.'

These failed attempts at essentialist definitions are like fibres in the thread that holds together, and have at times expanded, our understanding of what 'art' is. Each is only one of several recommendations to which we should pay special attention. Novitz (1996) further argues that we have a moral duty to consider these, even if they are necessarily socially and culturally biased.

This approach to explaining (rather than defining) a concept (and by extension, to explaining what 'art' is) has certain strengths over the essentialist approach. Firstly it gives a sociologically plausible account, which we can readily identify with, of how a community uses words in the absence of closed definition. Wittgenstein enjoins us to "look and see" at the context in which a word is used (aphorism 66) and again, in his lectures on aesthetics to "concentrate on the enormously complicated situation in which the aesthetic expression has its place" for "we don't start from certain words but from certain occasions or activities" (p. 1-2, Barrett, ed. 1978).

Secondly, it allows for the meaning of the word that describes a certain concept to evolve in step with how these concepts may evolve themselves (Warburton, 2003, p.37). This is precisely why, Weitz argues, 'art' *has* to be an open concept:

> "With "art" its conditions of application can never be exhaustively
> enumerated since new cases can always be envisaged or created
> by artists, or even nature, which could call for a decision on

> someone's part to extend or to close the old or to invent
> a new concept (e.g. "It's not a sculpture, it's a mobile.")[24]
> What I am arguing, then, is that the very expansive,
> adventurous character of art, its ever-present changes and
> novel creations, makes it logically impossible to ensure any
> set of defining properties. We can of course, chose to close
> the concept. But to do so with "art" or "tragedy" or
> "portraiture" etc., is ludicrous since it forecloses on the
> very condition of creativity in the arts." (p.32 Weitz, 1956)

Wittgenstein fails to prove that an essentialist definition of 'game' is impossible. The examples he provides are meant to show that no extant definitional criteria succeed in providing necessary and sufficient conditions but cannot preclude an eventual definition of 'game'[25].

Similarly, Weitz doesn't actually succeed in proving conclusively that an essentialist definition of 'art' is impossible. Osborne (1973) argues that such a conclusion is premature. Zerby (1957) argues that Weitz's paper seems both to define 'art' as an object and analyse 'art' as descriptive and evaluative. He also points out that even Weitz seems to prefer a non-essentialist definition to no definition at all. Wittgenstein and Weitz focus respectively on the 'game' and the 'work of art'. The definition of both would follow if one could convincingly define 'the activity of playing a game'[26] (Manser 1967) or , by extension 'the activity of making art'. A more general criticism of Wittgenstein's position is that the notion of recognition among family members presupposes, and does not explain, the basis for that membership (Davies, 1991; Manser, 1967; Osborne, 1973; Tilghman, 1973).

Weitz's argument that a closed definition forecloses on creativity doesn't seem tenable either: a sonnet is a closed form yet original ones can be created. Equally, one may conceive of a closed definition which evolves with time: for example, the word spinster might fall so out of fashion that the word bachelor would come to be defined as (1) a man or a woman (2) who is not married. All Weitz can show is that essential definitions to date are not successful. As with Wittgenstein for games, Weitz cannot exclude the eventual development of an essentialist definition. We could almost say that the assertion that 'art is an open concept' is itself open[27] – it is always possible that a set of necessary and sufficient conditions will be developed to close the concept.

Linguistic authority and cultural relativism

There is also the problem of relativity. Wittgenstein seems to readily admit that the open non-essentialist concepts are culture specific in his lectures on aesthetics:

> *'[expressions of aesthetic judgments play] a definite role in what we call a culture or period. To describe their use or to describe what you mean by a cultured taste, you have to describe a culture. What we now call a cultured taste perhaps didn't exist in the middle ages. An entirely different game is played in different ages.' (p.8., Barrett, ed 1978)*

Similarly Weitz (1956, p.32), concedes that the decision as to whether or not the concept of 'art' should be extended to a potential new instance of art, most often lies with the critics. But why should the decision not be weighed in favour of the opinion of the artists themselves or more democratically, by consulting the population at large? As it is, what is of-fered up by artists as 'art' seems forever out of synch with what critics are willing to appreciate as 'art' which is out of synch again with what the general public will agree is 'art'. Furthermore, if a new instance has to be incorporated into an existing open concept, there has to be not only consensus on the part of the language users but also as to which of the fibres of definition are more important: a new instance may resemble one aspect of the open concept but seem to be in contradiction to another. Which family resemblances are to prevail[28]? How can we avoid a situation of complete cultural relativism where disputes about art 'become part of a larger dispute about whose values and beliefs are worthy of serious attention, and whose cultural interests should prevail within a given society' (Novitz, 1996, p.156; similarly Osborne, 1973; Tilghman, 1973) or simply reflect personal tastes and preferences and hence be as numerous and varied as their are variations in human nature (Novitz, 1996;Osborne, 1973). Also, what family resemblances are we to invoke to distinguish a work of art like a readymade from its identical mass-produced counter-parts? (Danto, 1983)

How non-essentialism seems powerless in the face of intolerance

Even if an open concept based on family resemblances can sometimes be used to explain why we agree that certain things are works of art, an open concept seems less useful if one critic states that something is not 'art' and another wants to prove that it is. If one culture wants to destroy what another considers art (as the Taleban did with the Buddhas at Bamyan), invoking family resemblances will be a rather weak argument. If, on the other hand one had a logically consistent closed definition, especially one that did not 'fall prey to cultural and sociological value judgements'

(Novitz, 1996), one would hope to at least be siding with the authority of hard logic. It may be true that we tend to judge what is art and what is not from the comfort of our own familiar cultural preferences but if we make such an observation the basis of a definition of art then it follows that the Taleban could claim that to them the Buddha was not art, was objectionable and could be destroyed. If we want to absolutely condemn such an action, we would need to be able to generalise over and above cultural relativism. With a non-essentialist definition, one would have to wait and let time and custom decide, that is let history judge between one person's art and another person's garbage. In the meantime, the ends of Wittgenstein's thread seem doomed to remain permanently frayed.

Summary

I have put forward a new proposal to define art as a process of delimitation of a finite conscious experience for the purpose of re-evaluation or re-consideration. I developed this proposal in the context of an essentialist definition, as a set of necessary and sufficient conditions. I argued that such a definition has considerable explanatory power and in particular that it enables us to see why many controversial artworks are indeed rightly considered as art. The essentialist definition has many strengths: it is non-circular and definitions of 'artist' and 'artwork' follow from it; it does not depend on the artefactuality condition but handles the problem of 'indistinguishables' well; it allows for 'art' to take the most esoteric forms and be an experience, an event, a performance, an idea or a situation; it resolves situations of contested authorship; it is inclusive of anthropological art; it helps to explain the reiterative nature of the creative process; it rightly challenges the ability of Nature, animals and robots to be artists; it offers a distinction between craft and art. The difficulty remains of excluding processes such as business, philosophy and science that are not obviously artistic processes. However, the difficulty may only arise because these subjects involve a creative process actually rather akin to art.

I next investigated the proposal in the context of a Wittgensteinian non-essentialist approach to the definition of art, in which there is no single characteristic feature common to all art but rather a set of overlapping and mutually reinforcing family resemblances; individual fibres which together form a strong and usable thread. Weitz (1956) argues that no single art theory can hope to explain why "X is a work of art" but should instead be taken as a series of recommendations when we "look and see". While this is a sociologically plausible account and compatible with the boundary-pushing nature of contemporary art, it leaves the door open for a culturally relativistic assessment of what should be admitted as art and is not very strong in the face of intolerance. It does not explain which opinions or family resemblances should prevail when a

conflict arises. Finally, Wittgenstein and Weitz cannot exclude that essentialist definitions for 'game' and 'art' will eventually be found.

Even if my proposed Theory of Delimitation does not yet fully comply with the demands of essentialist definition, it offers a new and as I have shown highly useful and explanatory criteria for evaluation on which little emphasis has been placed to date[29]. As such, it would at the very least be a valuable strand in the thread of a non-essentialist, Wittgensteinian account and due to its explanatory and normative qualities, be a "serious and argued-for recommendation" (Weitz 1956) in the classificatory debate. Perhaps if the inclusive and tolerant theory of delimitation runs through the concept of art, some of the culture specific relativist problems inherent to the anti-essentialist approach can be overruled. Still, the problem with my theory is not that it doesn't provide necessary conditions but that it is possibly too inclusive. As such, it would be an unusual family resemblance in that it runs through all of the thread and protrudes at the ends.

Definitions of art can be classificatory and normative: "This is a work of art" also states that something must be respected and protected. But definitions should not be evaluative (Weitz, 1956). In particular, a work we dislike should not prompt us to exclaim "This is not a work of art". Instead we should ask ourselves two separate questions: Firstly, "Is this the result of art?" and only then, "Why do I not like it?" I believe that my definition gives a strong tool to address the first question even if we need to find out about the process behind the artwork and as such need to recognise (and trust) in the privileged position of the artist. The second question is about the public: how the result of this process of delimitation is to be interpreted, judged and valued by a critic would be an interesting extension of my work. But the normative achievement of my theory, is that it invites us to be more tolerant of 'works of art', of what people choose to delimit because it is important to them. Philosophy and art here have a relationship that is indissolubly linked.

Notes

[1]The concept of art as a process of delimitation is equally compatible with non-visual forms of art such as music and writing, as the above quote from James Joyce suggests.

[2]Both of these quotes are from Wittgenstein's Tractatus Logico Philosophicus

[3]Cf. Andre Malraux: "l'art est un anti-destin" (roughly translated as "art is an escape from fate"), Part IV, Chapter VII, Les voix du silence (1951).

[4]Cf. Louise Bourgeois:"Art is a guaranty of Sanity", printed on T-shirts, greeting cards etc... in Tate Modern shop.

[5]For an overview of many classic theories of art, see Davies (1991)

escape from fate"), Part IV, Chapter VII, Les voix du silence (1951).

[4]Cf. Louise Bourgeois:"Art is a guaranty of Sanity", printed on T-shirts, greeting cards etc... in Tate Modern shop.

[5]For an overview of many classic theories of art, see Davies (1991)

[6]See Bell's Significant Form Theory (Warburton 2005, section VII-54; Warburton 2003, Chapter 1), Kant's legacy (Freeland 2001, p. 10-15) and Tolstoy's Expression Theory (Ducasse 1944; Freeland 2001, p.155; Osborne et al. 2006, p.89; Weitz 1956), respectively.

[7]References for these are as follows: The institutional Theory (Dickie, 1974; Davies, 1991, Chapter 4; Wollheim, 1980, p.157); Significant Form theory (as in endnote 6.); Levinson's definition (Levinson, 1991; Novitz, 1996).

[8]Summarised by Davies (1991, p.143)

[9]Cf. Harold Rosenberg's 'Anxious objects' (Warburton, 2003, p.2)

[10]As in the artefactuality condition, Chapter 5, Davies, 1991.

[11]In contrast to the Institutional theory (see note 7 for references). In some ways my definition is like an extension of the Institutional theory where the Gallery is only one form of delimitation.

[12]The Ideal Theory, whereby 'art' can exist solely in the mind of the artist was first proposed by Croce and Collingwood in the 1930s (Collingwood,1968; Freeland, 2001, p.160-161; Warburton, 2003, Chapter 2; Weitz,1956; Wollheim 1980, §21-24)

[13]This is stark contrast to Beardsley's intentional fallacy (Warburton 2005, section VII-55; Davies 1991, Chapter 8)

[14]see note 7.

[15]This quote was part of the display at the exhibition The painting of Modern Life, Hayward Gallery, 2007.

[16]On the issue of authorship, I have claimed before that a tutor can become the author of work made by a student if he conceives of a different delimitation than the student which the tutor is more interested in re-visiting than the student himself.

[17]Though their culture became extinct in the early part of the 20th century, a few interviews with some surviving elders (shown at the Didima Centre for Rock Art, Drachenberg, Kwazulu-Natal, South Africa) give a rare insight into the meaning of the paintings.

[18]Similarly, artefacts found in the tombs of the pharaohs or of the first chinese emperor (cf. British Museum exhibition, 2007) can be seen as delimitations of important parts of the deceased's experiences with the particular caveat that these rulers expected to next appreciate their value in the afterlife.

[19]Francis Bacon: "You see, one has an intention, but what really happens comes about in working [...] And the way it works is really by the things that happen. In working you are really following this kind of cloud of sensation in yourself, but you don't know what it really is. And it's called instinct. And one's instinct fixes on certain things that have happened in the activity of applying the paint to the canvas" Sylvester (1993, p.148-149)

[20]See Croce & Collingwood's intuitionist approach (ref as for Ideal Theory, note 12)

[21]Danto notes that art is increasingly like philosophy (1998), a view criticised in turn by Warburton (2003, p.1-3).

[22]Traditionally, the Philosophical Investigations is referred to by the numbered aphorisms into which Wittgenstein had ordered his notes at the time of his death.

[23]Wittgenstein's choice of the word 'game' to explain the idea of open concepts and family resemblances, derives from his preceding discussion of language-games (as introduced in aphorism 7). The concept of 'language', he argues,

belongs to a type of concept comparable to that of 'game', an open concept to which individuals are confidents about assigning membership. Could one perhaps form a Wittgensteinian part of speech, a group of such concepts, of which 'art' would be a member but also 'science' and 'philosophy' and ethical termsin general? It is interesting to note that all these have in common that they need to be discussed both in terms of their functionality and of their procedures (which is also specific to art, see discussion of the functionalist-proceduralist divide in Chapter 2 of Definitions of Art (Davies, 1991)).

[24]Interestingly, it's not 'art', it's a 'game', pointing again to how the two are perhaps members of a particular class of concepts. There are those that argue (Hagberg 2007) that although Wittgenstein wrote very little directly on the subject, his interest in aesthetics underlies most of his philosophical views.

[25]His examples are actually quite unconvincing when set against Huizinga's proposed definition of games(as cited in Manser, 1967). Huizinga also considers the more interesting cases of Russian roulette, gladiatorial games, student debates, etc... His definition seems very good at explaining why these may be games to some people or in some contexts but not to others.

[26]Manser (1967, p.216) muses that "Indeed, it would not have been surprising if Wittgenstein had said: "don't think of games, but think rather of the activity of playing a game". In Philosophical Investigations, Wittgenstein makes no such clear distinction about the object and the activity but it seems that in his Tractatus Logico-Philosophicus, Wittgenstein wrote that Philosophy is not a teaching but an activity and that Philosophy should not be thought of as the sum of "philosophical propositions" but as an activity consisting in the logical clarification of thoughts (p.40, Heaton & Groves, 2005).

[27]In his reply to Weitz, Zerby (1957). argues that in order to rule out the possibility of a definition of art, Weitz has effectively but artificially closed the concept of 'definition'.

[28]An analysis of this problem with Wittgenstein's family resemblance approach to defining concepts is given by Manser (1967). In particular his discussion of Bambrough's Churchill Face (p.213) is very akin to my criticism of the application of family resemblances to art. Even if you can easily recognise a number of people as being from the same family, it's worth noting that a. it's easier to be sure if they are in the same family photograph (or are grouped for you in some way, prior to you having to judge whether they look alike) and b. you often mistakenly notice a family likeness in someone completely unrelated (e.g.: you look just like my friend Betty? Are you related? - Mostly the answer is no)

[29]I have not been able to find any comparable account in the literature (see bibliography for consulted sources).

Bibliography

Anscombe, G.E.M. & R. Rhees (2001) *Ludwig Wittgenstein: Philosophical Investigations* - The German Text with a Revised English Translation. Oxford: Blackwell

Barrett, C (Ed.) (1978) *Wittgenstein: Lectures and conversations on aesthetics, psychology & religious beliefs.* Oxford: Basil Blackwell.

Block, N., O. Flanagan, and G. Guzeldere (Eds.) (1998) T*he Nature of Consciousness: Philosophical Debates, Cambridge, Massachusetts and London,* England: Bradford Books, The MIT Press.

Bourriaud, N. (1998) *Relational Aesthetics Dijon,* France: LesPresses du Reel.

Collingwood, R.G. (1968) T*he Principles of Art* USA: Oxford University Press Inc.

Danto, A. C. (1983) *"Art, Philosophy, and the Philosophy of Art" Humanities* 4(1), 1-2.

Davies, S. (1991) *Definitions of Art*. Ithaca and London: Cornell University Press.

Dickie, G. (1974) *Art and the Aesthetic*. Ithaca, NY: Cornell University Press.

Ducasse, C. J. (1944) *Art, the critics and you*. New York: O. Piest.

Freeland, C. (2001) *But is it art?* U.S.A: Oxford University Press.

Hagberg, G. (2007) *Wittgenstein's Aesthetics* (internet) First edition Stanford

Encyclopedia of Philosophy. Available from http://plato.stanford.edu/entries/wittgenstein-aesthetics/ [accessed 12 June 2007]

Harrison, C. and P. Wood. (Eds.) (2003) *Art in theory*, 1900-2000: An Anthology of Changing Ideas Oxford: Blackwell Publishing.

Heaton, J. and J. Groves (2005) *Introducing Wittgenstein Royston,* UK: Icon Books Ltd.

Joyce, J. (2001) *A portrait of the Artist as a Young Man* Hertfordshire: Wordsworth Editions Limited.

Kennick, W.E. (1958) *"Does Traditional Aesthetics Rest on a Mistake?"* Mind 67, 317-334.

Levinson, J. (1991) *"Defining art historically"* Music, Art & Metaphysics (Cornell University Press) p.3-25

Manser, A, (1967) *"Games and Family Resemblances"* Philosophy, 42(161), 210-225

Novitz, D. (1996) *"Disputes about art"* The Journal of Aesthetics and Art Criticism 54(2),153-163

Osborne, H. (1973) *"Definition and Evaluation in Aesthetics"* The Philosophical Quarterly 23(90), 15-27

Osborne, R., D. Sturgis and N. Turner (2006) *Art Theory for beginners*. London: Zidane Press.

Pilkington, E. (2007) *My way or the highway. Art*s - Frieze Special (supplement), The Guardian, 12th of October, p.4-6.

Semin, D., T. Garb, D.B. Kuspitand G. Perec (1997) *Christian Boltanski*, London: Phaidon Press.

Sylvester, D. (1993) *Interviews with Francis Bacon* London: Thames & Hudson.

Tilghman, B.R. (1973) *"Wittgenstein, Games, and Art"* The Journal of Aesthetics and Art criticism 31(4), 517-524

Wagstaff Jr, S. (1966) *"Talking with Tony Smith"* Artforum 1(4), 18-19

Warburton, N. (2003) *The Art Question* New York: Routledge.

Warburton, N. (ed.) (2005) *Philosophy – Basic Readings,* 2nd edition London and New York: Routledge

Wegner, D.M. (2002) *The Illusion of Conscious Will* Cambridge, Massachusetts and London, England: Bradford Books, The MIT Press.

Weitz, M. (1956) *"The role of theory in Aesthetics"* The Journal of Aesthetics and Art Criticism, 15, 27-35

Wollheim, R. (1980) *Art and its objects*. Cambridge: Cambridge University Press.

Zerby, L.K. (1957) *"A reconsideration of the role of theory in aesthetics. A reply to Morris Weitz"* The Journal of Aesthetics and Art Criticism, 16(2), 253-255

TEN KEY ISSUES IN DIGITAL ARTS

Andy Stiff

This paper sets out to examine an area that is central to all discussion of the arts in contemporary society, that of digital art. Philosophically speaking it is an area that is very under-developed and open to new ideas, here I merely want to sketch out some key issues.

Digital Arts is a term that covers many disciplines within the Arts, so to define only ten issues will inevitably leave many important debates and developments out of the list. The items I have chosen seemed naturally to fit into two camps, namely structure and content. This duality can be seen as tools and ideas of digital practice.

STRUCTURE

01_The Network

In the 1960's the original incarnation of the internet called Arpanet (Advanced Research Projects Agency Network) was developed. What made this such an important event, was the new development called 'packet switching'.

Packet switching allowed information to be broken up into small units sent down a network cable that could be then recompiled so they make sense on another machine. Where previously a document could be shared across a network, one document to one computer, this new development allowed for many documents to be shared by many computers across the same network.

This is still the core technology behind the internet, and its subset 'The Web', that we use today. Although this technology is nearly 40 years old, its impact is still being felt, in both commerce and also the art world.

The 'web' was the first major development that offered opportunities to the artist. The web's origins go back to the early 80's, but it was in the early 90's whilst working at the particle physics laboratory, CERN, in Switzerland that Tim Berners-Lee developed what we call the web, the marriage of hypertext, and the internet.

By the mid nineties, the 'web' had really taken off, thanks to the Netscape Navigator web browser, the breakthrough was produced, and was made widely available, and free, to PC's and Mac's. Bill Gates at this time, described the web as a fad, and its was quite some time later before Microsoft developed their browser Internet Explorer.

Hypertext, was the early pioneers medium of choice, and the internet provided a perfect opportunity, for artists to explore freely. This leads on to why I consider networks to still be a critical issue in contemporary digital art scene. By producing art work that exist solely on the web, and that also engages with the functionality of the web, the traditional ground rules of the art world are being re-written. Galleries are no longer the only points of manifestation for an artists work. The display, timing and existence of art is in the control of the artist, not the gallery owner. This is beginning to open up lots of possibilities, and there has been a huge democratisation of opportunities for the artist. Festivals of new media art, web art etc. are common place, and these are usually run by artists, and the only criteria for selection is the quality of the work, and not its marketability. In some cases, usually the new or smaller festivals, they are more prone to invite artists to participate. Festivals such as Transmedia, Siggraph and most famously Ars Electronica offer us the potential to understand explore and view new media art, art that is designed to be viewed on your computer, at home work and in some cases on your mobile and PDA.

02_Convergence

This expansion of the network via wireless technology has meant that an artist can take their work to an even wider audience. The dynamics of a wireless network have led to developments in areas such as performance art, using ideas based around Flash Mobbing [the text message / internet

based event, where a large number of 'in the know' participants meet in a specific location and perform a series of activities utilising new technology]. There are also a number of games that are carried out using mobile devices and GPS. This involves the players moving around the real world, and here they can engage in a game, based in video reality. Here is a description from a website selling this type of game:

> *In location-based games, the real world serves as the game board. In order to "make a move" in the game, the player must move in the real world.*
>
> *Glofun games push GPS to its limits. Our games use standalone GPS, which means that the handset calculates the player's position, without network assistance, about once per second. Moreover, we perform sophisticated algorithms on the GPS lat/ long data to tailor the user experience to walking-speed movements.*
>
> *Tracking the player's location precisely and rapidly — throughout the game — increases a game's mental and physical intensity. The physical area of the game can be reduced to a more human scale, and smaller scale translates into faster game play. Glofun games can be played entirely within an area the size of a soccer field, or even a suburban backyard. Players' moves can be measured in seconds rather than minutes, so Glofun games have an immediacy that's not possible with yesterday's location technology.*

For the artist this means there is not only an expanded network with which to disseminate their work but also the format of the work is opened up. Not only can artists use games as a way of working they can use video, supplied on DVD, eDVD [a dvd with hyperlinks], the web etc. Basically artists are now making use of technological convergence, to be able to output their work in every manner possible, freed from the art-market.

03_Encryption

Encryption, can be described in a basic manner, as the process of converting digital files into a format where they cannot be understood without the necessary 'key' to decrypt them back into an understandable format. The most famous piece of encryption software is called PGP or Pretty Good Privacy.

Encryption, has had a major effect on how we understand and use the web. It is a tool that governments fear, that individuals insist is their right to decide on, and companies have mobilized to dominate the web by using it for their e-commerce operations.

Encryption has empowered the individual, information can be passed from computer to computer in a completely secure format. Only those

who have been given the key to decrypt the files can gain access. This has inevitably sparked a wide ranging debate around the issues of individual privacy and security, or the right of the individual over the right of the government and the law enforcement agencies, for access to computer files. Recently another issue developed. This concerned a normal user, whose home computer had been attacked by a piece of 'ransomware', which encrypted her hard disk and then demanded money from her to get a password to gain access to her computer files.

Historically hackers fall into two camps the old and the new hackers. The old hackers came out of MIT in the 1960's and their ethics are summarised here:

> *Thus, the ethical principles of the Hacker Ethic suggest it is the ethical duty of the hacker to remove barriers, liberate information, decentralize power, honor people based on their ability, and create things that are good and life-enhancing through computers. It remains an open question (of interpretation) as to whether it advocates the free distribution of software (the GNU/ Richard Stallman position), the injunction against using computers for malicious purposes (the Clifford Stoll position), or the need for secure networks based on trust (the Steven Levy position.) http:// www.fiu.edu/~mizrachs/ hackethic.html*

New Hackers have the following ethics:

> *So, in short, the new hacker ethic suggests that it is the ethical duty of new hackers (or the CU), to : 1) protect data and hardware 2) respect and protect privacy 3) utilize what is being wasted by others 4) exceed unnecessary restrictions 5) promote peoples' right to communicate 6) leave no traces 7) share data and software 8) be vigilant against cyber-tyranny and 9) test security and system integrity of computer systems. http://www.fiu.edu/~mizrachs/hackethic.html*

04_Open Source

Open source developed from many places, the hacker culture of the 1960's is often quoted as the origin, but the name 'Open Source' came out of a meeting held when Netscape announced they were to put the source code of their web browser 'Navigator' on the web free for download. The principle ethic for open source software, is defined by the Open Source Initiative:

> *The basic idea behind open source is very simple: When programmers can read, redistribute, and modify the source code for a piece of software, the software evolves. People improve it, people adapt it, people fix bugs. And this can happen at a speed that, if one is used to the slow pace of conventional software development, seems astonishing.*
>
> *We in the open source community have learned that this*

*rapid evolutionary process produces better software than
the traditional closed model, in which only a very few
programmers can see the source and everybody else must
blindly use an opaque block of bits. http://www.opensource.org/*

Open source software allows you access to its code, meaning that you can amend, add to the capability, customise or de-bug the software. This can be be done by anyone around he globe. Because of the sheer numbers of people testing adding and de-bugging a piece of software it means it is incredibly stable, has no security holes and above all the software is either free or charged at a very reasonable cost. The most famous piece of open source software is the Linux operating system.

05_Self Broadcast

The gallery and the gallery owner, followed from the artists patron, and supplied the opportunities for artists to exhibit their work, and build their reputation. This has never been an easy relationship, and the galleries and their owners have been portrayed as being the arbiters of art fashion, controlling who is 'in vogue' and who shall be held back until they feel the market is right. The expansion of the digital arena has transformed this relationship. Suddenly there are festivals of digital art and practices, there are online events and exhibitions displaying art or in some cases are the actual art in themselves. In the 21st Century the gallery has become less important for controlling what we see and what is available. Digital technology has done for art what the mp3 has done for the music industry, shifted power from the few to the masses.

The obvious medium for this change in the art market is the rise of the internet. This offers many possibilities to the artist the most important of which is the ability to exhibit and promote their work to an audience, that can view the work as many times as they wish from the comfort of their own homes and at any time they wish. There are web presentation tools such as Blog's and Wiki's that offer free, easy to manipulate websites. These do not require a knowledge of HTML, the structured language of the web, so content can be the focus, not the skills required to present that content. Broadband speed increases will ensure this medium will be offering the artist and the artists audience continued development and more complex and sophisticated work that utilises this medium.

The ipod has been the tool that has transformed the music industry, and the software technology that has enabled that revolution is itunes, which organises the the mp3 tracks, offers another opportunity to exhibit and promote work. 'Podcasting' is the term applied to the the process of converting, audio, stills and video into a format that will work on an ipod. These files can be uploaded to, and then downloaded from the itunes website, and this is a widely available platform, which is an independent and free method of disseminating work.

Technology has has also bought complex, expensive, tools such as video cameras and their editing suites to the desktop. So there has been a large growth in the number of artists using this medium. With DVD production capabilities also available on the average desktop computer, the artist can quite easily use this medium to publish their work. With web access speeds increasing the artist will soon be offering full resolution video, and even live performance art via the web.

01_ Dematerilised Data

Art's ability to visualise ideas straight form the artists mind, indicates it has had a long history in dealing with dematerialised data. Computers have expanded the role of dematerialised information, making the process bi-directional. Computers not only take ideas and convert them into 'pieces of art' but they can also take physical objects and convert them into digital code, to dematerialise them.

Once an item has been converted into digital information, binary code, the artist can repurpose that information. So a photograph can not only be cut up and recomposed, it can be animated, its attribute values can be re-used as co-ordinates, or sound levels or colour levels, or perhaps the outcome of the work can become a combination of these.

One of the key technologies, and a very basic computer skill, is the ability to cut and paste. This allows multiple duplications of the original that are identical in every respect, and therefore questions the whole notion of the authentic 'original'. The question of where it sits is at the heart of current digital debate surrounding artworks. What would the gallery, or private patron be buying? The work exists online, which means it can be viewed as an original by multiple viewers, at the same time anywhere in the world. It is only when an artwork is rematerialised in the form of a digital print, can the traditional value system be applied to it.

02_Web Technology

Web technology is continuing to develop. New combinations of coding languages are offering the artist greater creativity, with a set of coding languages designed for ease of use. A product like AJAX is one such technology and is described as:

> *Ajax, shorthand for Asynchronous JavaScript and XML, is a Web development technique for creating interactive web applications. The intent is to make web pages feel more responsive by exchanging small amounts of data with the server behind the scenes, so that the entire web page does not have to be reloaded each time the user makes a change. This is meant to increase the web page's interactivity, speed, and usability.*

Essentially AJAX is just s systemisation of existing technologies, and a simple and clear example of this is an application like 'Google World'. Here the application has been picked up and is used for projects such as 'Wheres Time Hubbard' - a site that allows you to follow the movements of the sites developer Time Hubbard.

AJAX is one kind of web based technology. There are still far more artists using applications such as Flash, and Director, as well as straight HTML. All these applications have a common theme, the use and interest in the global network itself.

03_Metadata

Metadata, or information about data, is one of the most important developments in the digital arena. There are the perhaps more obvious uses of such a system, such as logging information to a database, to expand retrievability in a search etc. But there are also some developments using the idea of metadata, such as Time Berners Lee's Semantic Web project. Lyotard famously commented on this area.

The aims of the semantic web project are focussed on standardising information about the knowledge contained within an html web page. Currently much of the data contained within web pages just remains there, and computers cannot re-purpose that information. So html pages rely upon human interaction and decision making. The semantic web will act like a giant database, that will turn all the data contained within web pages into information that is accessible, and understandable to humans and computers. The world wide web consortium describes the semantic web in the following way:

> The Semantic Web is a web of data. There is lots of data we all use every day, and its not part of the web. I can see my bank statements on the web, and my photographs, and I can see my appointments in a calendar. But can I see my photos in a calendar to see what I was doing when I took them? Can I see bank statement lines in a calendar?
>
> Why not? Because we don't have a web of data. Because data is controlled by applications, and each application keeps it to itself.
>
> The Semantic Web is about two things. It is about common formats for interchange of data, where on the original Web we only had interchange of documents. Also it is about language for recording how the data relates to real world objects. That allows a person, or a machine, to start off in one database, and then move through an unending set of databases which are connected not by wires but by being about the same thing.
> http://www.w3.org/2001/sw/

Another use for metadata, is the collection and presentation of information that supports and explores an artists work. Whilst running the online version of the MA in Digital Arts, I needed to find a process that would allow the staff and myself to be able to understand the history, context, development, aims and outcomes of the students work. Obviously studying on an online course your interaction with fellow students and staff is limited. This limitation also means that the methods of displaying and explaining any kind of work, needs to be very considered. I have encouraged students with the use of blogs to develop a collection of metadata, mainly image and text, that describe their projects in detail. This development on the course made me revisit the work of Gordon Matta-Clark, whose interests included the reworking of houses and buildings that were due for demolition. Consequently none of the original art survived, and all that remains is a visual and text based metadata of the processes surrounding the project. Many digital and new media artworks do have similar problems. The work still exists, but it is dematerialised, and coded. Much of the 'Art' is never seen, rather like an iceberg. Behind the object that is viewed by the audience, lies all of the programming and thinking that makes the work exist. So the viewer is left with the consequence of the artwork, not the artwork itself.

04_ Databashing

The database has been with us longer then the web, it was one of the first uses of computer technology. Yet the database is still at the forefront of artists using technology. Lev Manovich uses the database in his 'Soft Cinema' project. This project has many levels but at its heart is a database. The contents of the database are movie clips which are then recompiled in formats that are never repeated:

> SOFT CINEMA: Navigating the Database is the Soft Cinema
> project's first DVD published and distributed by The MIT Press
> (2005). Although the three films presented on the DVD
> reference the familiar genres of cinema, the process by which
> they were created and the resulting aesthetics fully belong to
> the software age. They demonstrate the possibilities of
> soft(ware) cinema - a 'cinema' in which human subjectivity and
> the variable choices made by custom software combine to
> create films that can run infinitely without ever exactly
> repeating the same image sequences, screen layouts and narratives.

The process is explained by Manovich here:

> Rather than beginning with a script and then creating media
> elements which visualise it, I investigate a different paradigm:
> starting with a large database and then generating narratives
> from it. In Soft Cinema, The media elements are selected from
> a database of a few hundred video clips to construct a
> potentially unlimited number of different short films.

This is a good example of the database, despite its longevity in the computer environment, as a continually evolving part of digital culture. The artists imagination and computer skills will be pushing the database to re-invigorate how we engage with all media not just computer media.

Swarm intelligence is another use of the database that is pushing the ideas of AI [artificial intelligence]. The principle here is the creation of objects that have an element of self organisation in a similar way to the idea of the semantic web.

> *The basic architecture of Swarm is the simulation of collections of concurrently interacting agents: with this architecture, we can implement a large variety of agent based models.*

So typically there are many people using this principle to invent robotic ants, and there is much talk of its use in nanotechnology as well, but as with Lev Manovich's use of the da-tabase artists will come to take this technology and push it to new possibilities.

05_Creative commons

Copyright has always been a contentious issue. When computers came along, and in particular with the expansion of the web, copyright has not developed to keep up with the technology.

This lack of appropriateness to the digital environment, and the growth of open source software, and also an acceptance of some of the issues raised by the hacker community led to the development of 'copyleft' and in particular the creative commons licensing system, that is particularly geared towards artists of all media.

> *Creative Commons licenses provide a flexible range of protections and freedoms for authors, artists, and educators. We have built upon the "all rights reserved" concept of traditional copyright to offer a voluntary "some rights reserved" approach. We're a nonprofit organization. All of our tools are free. http://www.creative-commons.org/*

This issue covers many areas, but this is an important and critical point for practicing artists to address. To understand how they're work will be seen and used is important. As with the open source and hacker debates, the community and co-operative ethics are behind this movement, which does irk the likes of Bill Gates, who was quoted as saying:

> *No, I'd say that of the world's economies, there's more that believe in intellectual property today than ever. There are fewer communists in the world today than there were. There are some new modern-day sort of communists who want to get rid of the incentive for musicians and moviemakers and software makers under various guises. They don't think that those incentives should exist. http://news.com.com/ Gates+taking+a+seat+in+your+den/2008-1041_3-5514121-4.html?tag=st.num*

Psychoanalysis and philosophy.

Kathy Kubicki

In the relationship of philosophy and art the question of creativity and the unconscious looms large; particularly since an understanding of the motivations of artists is ever more important within conceptual and critical art-practice. As the social definitions of art shift so does the necessity for rethinking how we define art. In critical terms we are looking at examining art as a specific form of neurosis where the critic explores the artwork in order to understand and expose the vicissitudes of the creator's psychological motivations, and how they relate to the viewer/reader.

In this area of creativity, psychoanalysis contributes a great deal. Many theoreticians and practitioners of art have explored the usefulness of this area of theory over the past thirty-five years. There is no doubt that previous to that there has been a strong link between art making and the psyche and Freud's famous essay on Leonardo mapped out a type of creative personality that we recognise still, neurotic (Beckman), obsessive (Bellmer), highly sexualized (Picasso), depressive (Pollock) and many other characteristics that are in no way flattering but certainly seem accurate, cliché or not.

This removes the single occupation of 'artist' to another realm separate from 'reality', the worst scenario according to Freud is punctuated by the demands of a lacking ego that needs constant nourishment and attention. We can also map this scenario onto contemporary artists such as Emin, Hirst, and Perry. Creativity is always extreme, outside of the parameters of normality, this Freudian analysis is correct for other creative pursuits apart from art making such as writing. There are a number of writers throughout the twentieth century that fit this mould. Writing for Freud was linked to daydreaming, the unconscious is a rich place where the unexpected occurs, where behaviour is translated as the reaction to frustrated desires and unlived fantasies.

Sigmund Freud is the formative practitioner of psychoanalysis who discovered 'the unconscious'. Exploring the areas of childhood experiences, repression, sexuality and the creative drive. His writings came out of a clinical practice, so it was what he heard in the consulting room from his patients on the couch that framed his theoretical discourse. Freud had his own analysis, was himself a perfectionist and an obsessive collector of primitive and tribal objects (see The Freud Museum in North London). Freud referred to psychoanalysis as 'the archeology of the mind, also he was anxious by the fact of having to validate his ideas to the scientific community which held much sway at the time (nineteenth century Vienna). Therefore his theories are written up extensively, and his case studies make fascinating reading. Psychiatry as we know it was new, the 'unconscious' as a place was hard to describe and to map out, after all it was not in a certain part of the body, could not be pathologised, as a concept it is challenging and obscure. However for Freud it had its own internal logic and he examined through the discourse of the clinic the 'unconscious' world of his patients, which 'manifested' in the forms of; the dream which he described this the royal road to the unconscious, parapaxes or everyday slips, jokes, splits in the personality, psychotic & neurotic behaviour. The symptoms were the way in; they opened the door for Freud. 'Manifest' things, actions, speech and dreams all held 'latent' meanings and a clue to what was troubling under the surface.

In his psychiatric work with psychotic schizophrenics when in hallucinatory states 'wish fulfillment' connected to taboo needs and desires was highly evident, and this became crucial to the work on dreams. As an example in 1894 Freud recounted the dream of a Medical Student who dreamed that he was at work in the Hospital early in the morning, and this to Freud was a clear example of a wish fulfillment as it meant that the student could remain in bed asleep and carry out his daily duties without exerting any effort. (Also an example of the 'Pleasure Principal' over the work ethos or 'Reality Principal'). Dreams were often jumbled, senseless and lacked a logically structure and it was by examining them in fine detail that a construction and sense could be made from them. For Freud

dreams contained 'The psychology of neurosis in a nutshell'.

The visual elements were part of this and comprise the essence of the formation of dreams and Freud describes this as picture writing, as in a cartoon, a visual representation replaces concrete objects. With analysis the latent deeper meaning of the dream takes precedent over the manifest dream as fragments are put together re-organised and laid out in inter-pretation. Within a dream sexual elements are replaced by non-sexual el-ements and expressed indirectly by, "hints, allusions and similar forms". This type of interpretation recalls ancient methods of dream analysis where symbolisation took place, but this was often primal and universal in content. (See also the writings of Carl Jung). Freud was quite specific, for example all material could be sexual, male are upright objects, female are containers, the sexual act as a staircase etc. The majority of dream symbols serve to represent persons, parts of the body and activities invested with erotic interest.

As individuals during the twentieth century we have become introspective and the demise of religion and community activity has heightened this trend. Philosophers such as Sartre and Neitche recognized the beginnings and Freud ensures that many of us now recognize this separate place (un-conscious) as a side to our lives, and repression as an inevitable outcome of civilised society, where desire cannot be fully lived out, order needs prioritizing (the 'reality' principal'). For Foucault this was a betrayal of human nature and desire, fetishism and perversion was outside of normality, the threshold that must be maintained is in itself painful (see Freud's essay 'Beyond the Pleasure Principal') and there is a price to pay for continuing to repress these taboo fantasies, they can seep to the sur-face during our every day encounters, unexpectedly and without warning and with sometimes pleasant, sometimes destructive consequences. The Surrealists recognized this and they battled amongst themselves as to the correct approach (Breton for the poetic chance encounter, versus Bataille for base materialism and filth). Surrealists loved Freud, he gave them access to taboo, primitive urges, Dali sent Freud his dreams to analyse. Equally Freud gained notoriety by association with the radical group of young artists and writers although clearly he paid more attention to classical art and antiquity in his writings.

Amongst the Post Freudian group of analysts Jacques Lacan has been the most influential in relation to writing about and making art. Lacan was ambitious in his re-writing of Freud, yet certain parts he left untouched. He came late to his main theories on language; he was 52 when his important papers The Agency of the Letter and The Function and Field of Speech and Language in Psychoanalysis were published. Lacan's seminars were famous. In 1968 he was barricaded in with students in The Sorbonne in Paris, he was also expelled from the International Psychoanalytical

Association because his theories were too philosophical and not linked to the clinical world. Lacan's interests were also in the nature and function of fantasy and the arguments in relation to biology versus culture. He believed that therapy could alter your character if early enough and successful, but he also believed there were limits to the love and hate that all individuals have.

Lacan recognized that language is crucial especially in the 'transference' in therapy; the 'force field of the clinical encounter' via language is the way the therapeutic relationship is worked through. Communication during the therapy is itself to be analysed as Lacan takes its verbalism and talkativeness seriously. The gaps and pauses were of equal importance, the utterances and spluttering all transferred meaning (Lacan's famous quote, 'a letter always reaches it's destination'). This is true of all communication and verbal encounters, personal or otherwise. Lacan's theories could be mapped onto society and its structures, and to art and art criticism as the meaning of an artwork is translated through the object and also what surrounds it, the discourse, the transaction and effect.

Working within a feminist framework in the 1970's and later on, Mary Kelly was one of the first to recognize the usefulness of Lacan's theories on language as a symbolic order that prevented women from entering the institutional base of art (and most areas of life) and challenged this through her artwork that chose the everyday activities of women as her subject matter. Post Partum Document is a collective archive of material from the early years of her son's life. She played with language and re-formed another methodology that prioritised these activities. She has been criticised by some for being too theoretical but there is no doubt of the radical nature of her art practice that displayed in the gallery objects such as nappies and photos, scribbling and clothes, which means they also sit intelligently within the post modern tradition. Martha Rosler examined the symbolic order in her video work Semiotics of the Kitchen where she mimicked a cookery show, miming in a brilliant performance the chopping and banal mind numbing activities in a hilarious and irreverent artwork.

Narcissism also features strongly in Lacan's theories, in terms of love and identification of the 'other'. He used the idea of the 'mirror'. During the 'mirror stage' in his or her reflection for the infant aged around 18 months there is a species identification (I am human) and an ego ideal (I am me). The splendid and perfect spatial mirror reflection the infant glimpses of himself cannot be mapped onto his real body image as he glances down at fragmented limbs (orthopedic) and flaying joints, the self is miss-assembled, imperfect and made of flesh and blood. Lacan recognises that there is always a gap between these two primary visions that we carry through life, a disjuncture, a split (body in pieces) and an inveiglement, a ruse a miss identification that fills desire and fantasy in opposition to the real.

This part of Lacan's theory has been extremely useful in the making and analysing of artworks particularly in the last 25 years were the body has been used as a metaphor for post modern existence, as a fetish, as a allegory for modern medicine and disease, and as a expression of desire, repression and sublimation. Installation, performance, video and photographic work in particular maps onto these notions, Cindy Sherman, Robert Gober, Robert Mapplethorpe, Marina Abramovic, John Coplans, Sarah Lucas, Joel Peter Witkin, Paul Mac Carthy. Franko B to name but a few.

At the same time the French Feminists such as Julia Kristeva and Luce Irigaray have formulated their own theories as an extension to Lacan's. Kristeva is a philosopher and humanist, an analyst a writer and a cultural commentator who in her writings emphasises the mother daughter relationship, and explores a time before the Oedipal (father son) conflict that Freud had previously prioritized in his writings on sexuality. The 'semiotic' according to Kristeva is a place like the unconscious, it is pre linguistic, a time before birth when language is outside of the symbolic order. Here the pulses, sounds and rhythms form an important and primal experience of language, which is described as 'poetic' by Kristeva and linked to the feminine. Her important essay on the 'Abject' re-assesses Freud's death drive and positions a real and post modern dilemma which lurks deep within the collective psyche which is our difficult relationship with death on an intellectual level, particularly with the dead body. Lifeless and still, grey and stiff, decaying and horrific, difficulties in identification and disgust are part of the trauma. Art that uses body fluids, references death and desire, trauma and elation ('jouissance') are part of an expression of a process that keeps us on the brink of knowing yet never fully knowledgeable. As producers and/or the audience of art we are no longer connoisseurs but always becoming, as we employ psychoanalysis and it's rich discourse and history to art and criticism we are able to recognise that meanings are no longer fixed, but fluid, transitory and many layered. As Roland Barthes famous essay espoused the authors are no longer the producers of meaning.

Bibliorgraphy

Freud, Sigmund. *On Creativity and the Unconscious: Papers on the Psychology of Art, Literature*, Love, Religion. 1976

Neumann, Eric. *Art and the Creative Unconscious:* Four Essays. Routledge. 1999.

Osborne, Richard. *Freud for Beginners*, Zidane Press, 2007.

RENDER VISIBLE

Marty St. James

Where do I go when I want to get pixilated?
Paul Klee

Key Issues

What are some of the key issues that an art student should be asking themselves on reflecting upon and engaging with the relationship between fine art and the global digital revolution at the beginning of the 21st Century? How is philosophy a useful tool in this area?

Introduction

As photography both disturbed and re adjusted the medium of painting, and the moving image changed and endorsed our perception of time and movement the invention and delivery of a truly global technology is forcing artists to reconsider and relocate their understanding and use of materials in this 'brave new world' of globalised inter-connected social and political exposures.

And almost suddenly a developing global technology steps through the door to add 'an other' dimension. A medium, a collective, a communication tool, a statute, a new modality; to assemble things using pixels. Along with this come new theories, new ideas, debates, and discourses, on manufacture, ownership, copyright, decision and indecision.

Part of the job of the fine artist is to energize, locate and set about innovation via process, thoughts, feelings and ideas in order to reach further dialogues, discourse and most importantly adding to one's understanding and how contemporary 'consciousness' operates, what it is and what could it be? To develop a stance, a position.

My own concerns as an artist have taken me through a series of connected envelopes. Elements to do with TIME. What was once time based media, performance art, video art, sound, installation and the digital. In search of a sense of the sculptural in time and space. Always locating a sense of the 'Betweeness of Things'. From social inter-active live art works on the street, on a ferry or in a shopping centre to popular cultural video journeys, video portraits and digital installations. An intention to transcend situations via formal structures and moving images/actions have often been at the centre of my practice as a fine artist.

The creative mind never rests – it collects, collates assimilation processes, digests, regurgitates, processes, envelopes and presents. But it does not necessarily have to please us, make communication, illustrate or make sense. It should be a test for us, pushing our awareness of our sense of 'etre' further. Presenting new potential at that time for 'all' to see. Fine art is often at its most potent when disposed to its most useless as an 'item or thing'.

"Rendering the invisible: the problem of painting .."

*"For there is a community of the arts, a common problem.
In art, and painting as in music, it is not a matter of
reproducing or inventing forms, but of capturing forces."
Gilles Deleuze p40 Francis Bacon: Painting Forces Chapter 8*

*"Not to render the visible but to render visible"
Paul Klees famous formula*

"Fantasy, abandoned by reason, produces impossible monsters; united with it, she is the mother of the arts and the origin of marvels." Francisco de Goya

*"Art isn't being made any more, its just being looked at! ",
Martin Kippenberger from an interview with Jutta Koether
(1991).*

Where is the real?

The Postmodern belief is there is no Absolute Truth and this has detrimentally affected modern Art, resulting in artistic confusion, lack of meaning and decay.

On post-modernism the French cultural theorist and philosopher Jean Baudrillard talks of "postmodernity, which is the immense process of the destruction of meaning". By the destruction of meaning he means the

destruction of what had been called "meaning" by its redefinition as appearance – the introduction of the hyperreal. He considers the idea of art being a playful process - he considers the decline of absolute truths. There is no single paradigm.

In an exhibition my work was shown in entitled, 'Codes of Culture', Buenos Aires, Argentina (May 2006), a collection of artists works from across the globe were presented. "A globalization debate is taking place", wrote the curator Nina Colosi," how this affects art and artists is interesting. As the 'modern' approach was unsettled from its 'definites' is it that technology is re-locating the person in time and space forcing the artist to re-read how 'things' are in a global sense. Asking questions like, 'does this image mean the same in South America as in Europe or can they be pulled apart?"

Baudrillard constantly poses this question, and the idea of the hyper-real, of the simulacrum, invades all contemporary art practice. The creation of a reality (of a virtual reality) poses the question of how is this attached, determined by a technology and led by multi-nationals and industry?

In a sense digital technology ironically could be said to fit the postmodern theory of collectivism, bringing together the previous highbrow culture and low elements of pop culture. Absorbing in one art form of image and content in one swoop of a button. Here our sense of study and understanding of history is exploded into a sort of irrelevant/anything goes scenario.

Lets playfully consider the following questions and answers?

Positioning and re-positioning ourselves as artists

Person A: What is a painting?

Person B: It's a big flat thing that hangs on a wall and is made of paint on canvas or board. It usually has colour and is generally applied paint with a brush or pallet knife.

True?

Person C: But I beg to differ it can be all of those things and a lot more! It can be quite a number of things for example it could be:
...Virtual (you can now continue yourself...)
....

So we can apply this same sense of questioning to a number of issues related to the practice of fine art in the global digital age. Consider the following:

Has, as suggested above our view of painting changed due to a current global technological connection?

Where do we stand in relation to art history at this point in time given these changes?

Has our social and political thinking transformed itself or made a shift with the availability of such immediate access to information? for example thoughts around the Olympics and Chinas occupation of Tibet how have our thoughts and capacity to analyse this information been transformed?

What is copyright or ownership now? Has this broken down into a near meltdown situation? Consider pop music as an example and the spread of the download.

Why is it that the art market in a time of mass information and available identical copying been able to flourish?

What are the different meanings of things here to the meaning of things over there? Does an image made in Birmingham or Glasgow mean the same to a person in Buenos Aires or Tokyo or New Delhi? Has there been a shift or are we amongst a change in values and understanding?

So where does the artist find wisdom? And do they need it?

As many questions are being asked as being answered. For the fine artist a sense of striving of where and what is consciousness prevails. How do we contribute to a contemporary view of what it might be at our time in history?

Well maybe it's about a position, taking up a stance, locating an area that you can and want to defend. There are many ideas, theories and positions, Art Theory is filled with a whole century of them and that's only the ones we know have been written about. Well its good to start with I'm a painter or sculptor or indeed 'I am a Real Artist', as Keith Anatt demonstrated in the 1960's .

BOB: So it's about position?

LILY: Yes but also choice and decisions.

BOB: What decisions?

LILY: Decisions of choice, stance, need and requirement. E.g. materials are a good staring point. Real or Virtual.

BOB: Oh……

Marty St. James, who invented the video por-
trait, has worked primarily across performance
art, video art and drawing. Exploring the physical,
the electric and the pencil, as he describes it.
A timebased media /digital artist straddling
modernist and post-modernist times.

His work locates itself between the narrative
of meaning and the meaninglessness of re-as-
semblage. A type of visual Beckett. St.James
has exhibited in leading museums and galleries
in the US, Europe, Russia, South America and
Japan. He is currently the Professor of Fine Art
at the University of Hertfordshire.

Türkiye, Hybridity and Me

Halime Özdemir

When one thinks of Turkey as a nation depending upon which generation the judgment is passed by the perceptions of identity and the notions of possible *hybridism* are very contradictory to the fact that, Turkey as a we know it today is a relatively new culmination of peoples. In the *past 100 years* has been through the transition of being an imperialistic gigantic Arab empire (*the ottoman one of course*) which had reigned for centuries prior and notably had claims on a large portion on the *Europe* we know today as well stretching across today's *Arab* nations to; the up and coming fashionable contemporary metropolis that is Istanbul or the new (*investment*) idyllic *Aegean* and *Mediterranean* coastline. I feel at this time I need not go into the reign of *Atilla the Hun* and the *Mongols* prior to these findings as that would be straying off the very profound points in which I would like to stress...

We have as a world witnessed the diverse and radical changes in the, metaphorically speaking '*climate*' of Turkey. The transition from the Arab *language* and *alphabet* in early 20th Century to the adoption of the New,

Latin formatted *text* which thus created the *bridge* and *fusion* of the *Arab* tongue and Latin *language* creating the Turkish language today. In the simplest of forms the very fusion of the cross continental language barriers is vital in understanding somewhat the significance and nature of *hybridity* and the later *evolution* of certain aspects of society and culture especially within the language there is evidence of '*linguistic cross breeding*' and the use of loan words as a result of such a fusion.

One of the most disputed areas I feel when discussing '*hybridity*' are that common references are made in

"... the creation of new transcultural forms within the contact zone produced by colonisation."

Whereas that is just a restriction to the parallel that *Hybridisation* takes on many forms such as; *cultural, political* and *linguistic*. The perfect example for this of course is the *Istanbul* of today.

With Turkey's rapid modernization and economic need becoming as well as creating a catalyst for producing a more hybridized and a less homogenous landscape, rethinking *Modernity* and *National Identity* in Turkey is vital when considering the interrelation between the villager and the city dwellers architectural choices and the ongoing social and cultural customs as well as the expanding growing need for economic and social growth thus, offering a framework by which to analyze a new domestic lifestyle alongside the old in this moment of broad transition and evolution.

The transition and evolution is very much apparent in the *Istanbul* of today. The vibrant and rapid growth of a large number of *contemporary modern arts, cinema, literary* and *media* movements notable supported and pushed by *Arts councils* and private gallery ownerships *International Bienals, Film Festivals (IKSV) Literature (Orhan Pamuk)* becoming more open to external influence are in fact the catalyst for further growth and acceptance to a more modern and contemporary view on Turkey and its people. Long since the time of when you thought *Art, literature* and Turkey you would only think *Ottoman* or *Iznik*.

In a article (2005) in the *New Statesman, Alev Adil* stated that, along with *Orhan Pamuk,* (author of *My Name is Red*) *Perihan Magden* (ex columnist for *Yeni Aktuel*) was

'*among Turkey's most convincing ambassadors as the country bids to join the EU*'

because she elucidates

'*the complex and compelling hybridity of modern Turkey*'.

As a practising mixed media artist with recent exhibitions in *The Menier Gallary, London* (May 2007) and currently producing work for *Mondo Chic, Spain* and working towards participating for *Malaga 2016 European Capital Culture* (indirect drawing through mono-print, dry-point etching, photography, sketching, screen-print, oil based painting and film) the movement and ripples flowing through *Istanbul* at present are very exiting. I work namely by the principle of *Drawing*. To me this not is not just about the transference of an image onto a surface. It's about *"drawing"* from what you *touch, see, smell, hear, think, sense* and *feel*. Drawing is not just about aesthetics. It is a vital tool in the aid of understanding and translating ones personal language and I feel very much that *Istanbul* is reaching out and is beginning to '*draw*'.

For the sake of formalities Turkeys Capital city isn't *Istanbul* but there is no disputing that *Istanbul* is and has been for many centuries the *Cultural hub* as it were of Turkey. The pathway to *Europe*, the bridge onto *Asia*. *Istanbul* has the characteristic of any countries capital city. People flock to *Istanbul* for work, careers advancement of ones self, the media, the arts, hopes, dreams and aspirations are embedded into its vision.

Bibliography

Ashcroft,B., G Griffiths and H Tiffin. *Post-Colonial Studies: The Key Concepts*. London: Routledge, 2003. p. 118

Web
http://iaps.scix.net/cgi-bin/works/Show?1202bm411

http://www.indexonline.org/en/news/articles/2006/2/turkey-magden-trial-adjourned.shtml

http://www.qub.ac.uk/schools/SchoolofEnglish/imperial/key-concepts/Hybridity.htm#_ftn3

Kant, Breton and Revolution in a line

Bess Frimodig

The artist's print which is steeped in humanism can be experienced first hand and solely as a thing of beauty. Yet, looking closer, a narrative outlining plight emerges. Pathos and protest surge through the lines.

As a printmaker, I feel that I am connected through a long line of artists who cried out against crimes to the living through their imagery. Artists against feudal abuse of peasants like Bosch, Brueghel and Durer. Daumier drew and printed against an oppressive regime in 19th century France, while in the 20th century Ben Shahn pushed his scriber's needle against the atomic bomb.

Initially, and as a younger artist, I was only drawn to the visual quality of their work, and not the underlying message of protest. I discovered that later emerging though my own travels and internal battles. The close relationship between the etched line, according to Adorno, is submerged beneath the paper and sets up another reason for being than just to behold.

This looking closer, this gaze, as discussed by Kant, is an act which beauty may satisfy and please, but drawn in empathy, such a print irritates a viewer's complacency.

Kant's legacy of humanism discusses the universal, but not as suffering, but as spirit. The humanist seeks to understand rather than to know and to integrate the spirit in one's practice. A print to me, is a humanist art form- democratic in its history of shared working practices, craft, relatively low production cost and legacy of social engagement.

My world demands of me is to interpret the experience of being human through the lines in the print- and where a mix of horror, pathos and aesthetic pleasure ensnare each other. I cannot escape my own tendency to seek pleasure- in the line, and in the form. I can not escape the cries of the world.

Nevertheless, this could be a creative self- imposition. Kant argues that we live by our own narratives, and to a degree, have to accept our lives to be fiction. Nevertheless, the fiction is powerful enough to drive us to do things, and to make this internal narrative meaningful to our selves. The art of humanism draw on on the narrative, incorporating para-digmatic particularity to share universal stories through the individual.

As such, I can only strive to be a humanist under the influence of Kant and quote Breton who said 'Lyricism begins the revolution'.

Expression through Fetishism

Anastasia Sichkarenko

One of the important questions in respect of philosophy and art is that relating to the 'normal', for a long time historically it was felt that art should deal only with elevated or proper concerns. The twentieth century revolution in art overthrew that search for moral conformity and unleashed a critical torrent of questions about how art should confront reality. From Baudelaire to Surrealism the borders of 'normalcy' were attacked and the further reaches of the unconscious were discovered and explored. The outer limits of such exploration began to theorize sexuality, perversion, trans-gender and Fetish, which is what concerns us here. There are many definitions of what is Fetish or Fetishism, some are quite different from contemporary associations with sexual abnormalities. Throughout history the concept of fetish was used to represent various things within society.

A fetish (from French *fétiche*; from Portugese *feitiço*; from Latin *facticius*, "artificial" and *facere*, "to make"). The word was first used by Charles de Brosses in 1757, as he compared West African religion to the

magical aspects of Ancient Egyptian mythology. He stated that Fetish is an object believed to have supernatural powers, or in particular a man-made object that has power over people or forces of nature. Blood for example is a particulary strong fetish or ingredient in fetishes, in ancient South American Maya and Aztec cultures. Other Fetishes of the ancient cultures world wide included bones, fur, claws, feathers, water from certain places, particular types of plants, and wood.

Charles de Brosses and other 18th century scholars used the concept of Fetishes- the objects of worship- to construct an evolutionary theory of religion presuming that societies progress from fetishes and totems to more complex and diverse forms of worship.

To Karl Marx fetishism showed how people mistakenly ascribe power to certain objects that do not hold any real value, he used this idea in his "commodity fetishism" theory where he identified such strange thought systems at the heart of modern society. Our belief that private property has a central role in modern capitalist society is not dissimilar to Celtic beliefs that heads chopped off their enemies were powerful magical objects. In contemporary society consumer objects often have power over our actions, and us.

There is no surprise that fetishes found thir way into the field of psychology. In 1887, psychologist Alfred Binet introduced the term fetishism, he believed that sexual fetishism is sexual arousal that is satisfied through an inanimate object which somehow becomes associated with sexual arousal. So it is a pathological result of associations gone wrong.

The theory of erotic symbolism, according to which unusual sexual practice symbolically replaced normal sexual intercourse, was introduced by Havelock Ellis in 1900. This and his presumptions about erotic thoughts in children, had laid the foundations for psychoanalyst Sigmund Freud.

Freud had also studied culture and the religion of primitive tribes and societies, exploring the concepts of totems and taboos; he however linked those religious practices to unconciousness fears and anxieties all humans have and supress. In 1927, Freud stated that fetishism was the result of a psychological trauma. A boy, longing to see his mother's penis, averts his eyes in horror when he discovers that she has none. To overcome the resulting castration anxiety he creates a fetish as a substitute for the missing genital. This fetish makes women tolerable sexual partners, as Freud presumed, never however commenting on the idea of female fetishists.

According to modern mental health criterias such as the International Statistical Classification of Diseases and Related Health Problems (ICD), fetishism is the fixation on an inanimate object, or body part. After

M AN M ACHINES

Sigmund Freud published his psychoanalytic view of fetishism the term become popular with non-scientific readers. While in psychology fetishism is classified as sexual psychological disorder, in popular culture it became a kitsch term used to describe commonly fetishized items such as shoes, lingerie, and specific materials such as satin, leather or fur.

Freud's theories of the unconscious mind and his views of fetishism become very popular with many artists in the 20th century who wished to explore the other reaches of the psyche and to bring all the fetishes out of the unconscious into the open. Such artists rely heavily on Freud's terms such as anxiety, inhibition and repression in their work as well as bringing their own themes into the field.

Gottfried Helnwein (Face It 2006) for example portrays fetishistic obsessions with the military and aggression but to me an interesting interpretation of his work emerges when we consider a more philosophical rather than psychological issue of breaking down fixed gender roles in contemporary culture and the fetishistic notions that came out of that.

Fetishism is particularly popular in contemporary gothic culture especially with the new Gothic Lolita style that have emerged in Japan. This can be seen in the works of artists such as Trevor Brown (Forbidden Fruit 2001) and Junko Mizuno (Hell Babies 2001) as they investigate the role fetishism has in contemporary youth culture.

In the West Pop Surrealists such as Todd Schorr (Dremland 2004) and Mark Ryden look at ways to represent commodity fetishism showing us what kind of objects are being fetishised in western culture starting from the beginning of the 1950's to the present times. Mark Ryden in particular adresses the cult of celebrities and their impact on our society.

My own work looks at fetishes associated with the interaction between humans and technology and the resultant change within our perception of the human body in contemporary society. Fetishism and perception are linked in many complicated ways, seeing is being seen.

I AM NEITHER ALIVE NOR DEAD

THE WEIGHT OF LOVE, OF MEANING

Derrida:
An Interpretation of
the Destruction of Fantasy.
Emmet O'Farrell

The dichotomy between the inner intuitive medium of meaning and its quantitative and artificial representation in the real world through technology was what brought my research into philosophy, and Derrida.

Phonocentricism is a salient idea and metaphor adherent to the principle that artificial and quantitative reproduction of speech through writing and text is destructive. Derrida states that the voice is the privileged medium of meaning. In the inherent human process of thought becoming speech, speech becoming meaning. Phonocentricism argues that quantifying speech into text and alternatively visual reproduction of such is destructive to this inherent process and unstable.

In his article 'Signature Event Context', concerning the hierarchy of speech over writing. Derrida emphasizes writing and text as merely an "operation of supplementation 'or' a modification of presence", the "presence" being what speech is effectively supposed to carry. Indeed

the hierarchy of speech existed before Derrida. Plato and Rousseau have also expressed scepticism about writing, feeling that written works are inherently inferior to oral teaching methods.

I created a Video piece in the form of a poem, which deals with the advent of quantitative, structural and systemic integration with our sense of meaning, presence and evanescent corporeal identity adherent to the principle of phonocentricism. As a metaphorical reaction to the integration of technology; technology as an unnatural evolution. By use of text projected onto the body and face of a narrator it acts as a coarse representation of the poem, of expression as we cannot hear the narrator's voice. We cannot hear the emotional presence.

I see technology as an unnatural evolution detaching and disenchanting us from our corporeal and expressive natural state in its representation of human presence, human emotion and expression. As evolutionary patterns are usually an inherent reaction to immediate terra and natural environment. Technological Integration is essentially a Promethean experiment that we are blindly incorporating in our global interpretation and artificial communication of meaning. Gently a destruction of fantasy emerges in the form of mercurial endeavour as we effectively like Prometheus reach to steal fire from the gods only to receive Pandora's box.

Philosophical Question: agreeing with and opposing Derrida; relating and re-relating

Sophie Reed.

Inhabiting the shifting complex of relations that is *now* seems to ensure that we are in a continual state of reconfiguring the ways in which things relate. I construct spaces whose changing structures require the viewer to adopt a similar *ongoing* process of **relating** and **re-relating**.

The above is typical insofar as an observation of an inherent indeterminacy, or *endlessness* that is associated with the pursuit of meaning in current culture in general - is coupled with the connected creative attempt to mirror aspects of this unfixed nature in both the production and encouraged reception of an artwork. The formal setting out of these ideas has indeed been prominent (if not completely exhausted) through all forms of criticism over the last 30 years. I will explore the types of relationships that are present in my work and that are echoed throughout this complexly theorized space with specific reference to *Jacques Derrida*[1].

[1]Jacques Derrida's Poststructuralist writings of the 60s and 70s provide a particularly radical example of this area – or, of that of the debate that is associated with postmodernism. I am interested in specifically referring to Derrida partly because of the fact that his name is widely assumed synonymous with this movement.

In my work *Shifting (2007)*, a projected moving-image unfolds an ambiguous 3-dimensional model-space (loosely reminiscent of architecture) that is transforming. As the piece develops, the viewer is invited to attempt to realise the represented space's whole through a series of successive camera viewpoints that reposition around the object. In prompting a *gradual negotiation* of the essentially *unfixable* space's parts and subsequent linkage, I am concerned with producing artworks that on one level act as metaphor for a wider process of striving to fix knowledge in an uncertain contemporary context. In this work however, a visual negotiation of *perceived* structure also takes place: *in between* that of the building of additional elements - and a moving light-source that in turn both effects shadow objects to continually reconstruct, and entire areas to move in and out of visibility. As the viewer watches the repeated mysterious moving-image fragment, they may gradually discern a sense of an *emerging structure*.

In Jacques Derrida's 'Of Grammatology' of 1967, he posed his philosophical concept of the play of *Differance* in language. In short, this included the idea of an endless *deferral* of all meaning in the world by stating that single meanings can be considered only in the terms that they are one part of a chain of signified 'signs'. This operation worked on the basis that if an individual sign's nature has been directly contrived from one that came before it in the sequence and in turn simultaneously points to another sign, the process is thus unfixable and meaning is impossible

to define at any point. Similarly, an origin or central meaning cannot be assumed to exist. Significantly, I am neither concerned with illustrating the truth of this, nor of providing evidence for Derrida's counterparts' similar claims. I am moreover interested in the outstanding legacy and everyday assimilation of such ideas: of the collective attitude in this current conjuncture to only class insight as preliminary signs for example, or of the very real sensation that things seem impossible to pin down, or position in relation to one another. I am interested in using and evoking aspects of this sensation in the spaces that I make. However, in place of where this primary confusion often tips into an accompanying feeling of meaninglessness in real life, I look to constructing scenarios where connections in perceived structure *may* be gradually built in between and in spite of their flux.

To reiterate: crucially, there is a split reasoning in the reference to Derrida within my work. On one hand I look to mirroring those elements that I have already identified in the world that resemble a process of *Differance* (such as the sense of an ongoing movement, or the incessant act of re-relation). However, by way of encouraging a degree of culmination, or lasting impression of affinities between parts that initially appeared unrelated, I aim overall *conversely*: so as to prevent deferral and thus to counter, or work against Derrida[2].

[2]Again, to clarify - my critique on Derrida points concurrently towards the wider theoretical context of postmodernism.

An examination of the idea of the 'Numinous' in Contemporary art practice

Jungu Yoon

How the idea of the 'Numinous' is represented in a world in which secular ideas are increasingly dominant is the key philosophical question for me.

I use the term 'Numinous' derived from the Latin 'numen' to clearly differentiate it from the more traditional religious meaning of 'Holiness'. Art and religion have always stood together historically. It is then, as Rudolf Otto knew so well, that 'numinous' can not be expressed by means of anything else, just because it is so primary and elementary a datum in our psychical life, and therefore only definable through itself. But the artist, who for his part has an intimate personal knowledge of the distinctive element in the aesthetic experience, declines his theories with thanks.

Interestingly, one of the most familiar Eastern terminologies 'Kiun (spirit resonance)' has a comparable meaning with Otto's definition of 'numinous'. 'Kiun' has a character that is energetic and dynamic and is impossible to define in a word due to its being abstract.

My research will be mainly informed by the theory of Rudolf Otto, and, additionally, aims to relate how the East Asian term of 'Kiun' as interpreted by modern sense and sensitivity can be applied to contemporary creative activities, and to explore whether the ideality of 'Kiun' transferred into visualization in art.

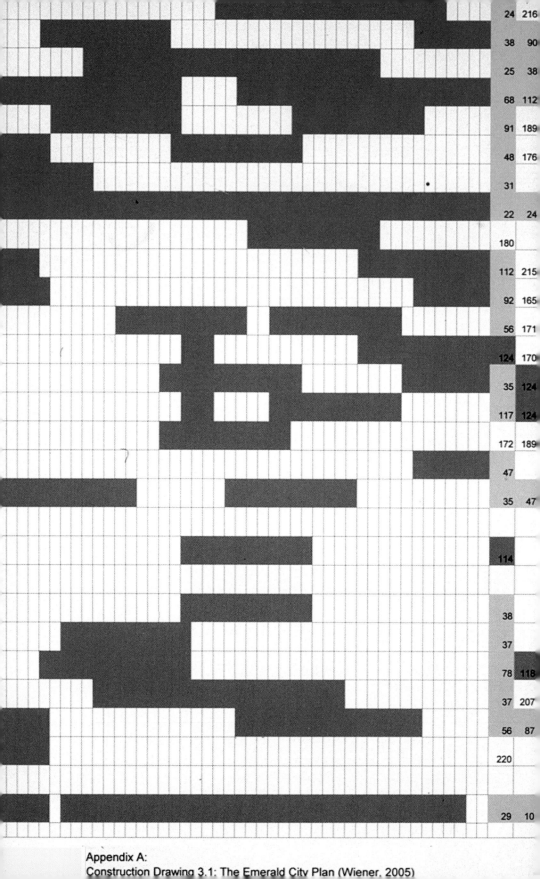

Appendix A:
Construction Drawing 3.1: The Emerald City Plan (Wiener, 2005)

General Process: Image and Idea.

Jenny Wiener

The core philosophical question for artists is how to conceptualise realities; how to think about the mythic space-time continuum we operate in and how we plan and function within it. It's relationship to the laws of physics underpins this questions.

In my work drawing and construction were used to measure and combine unseen results and produce new arrangements of the Emerald City. Using drawing as thinking, I mapped my research and built my arguments using flipchart and process drawings. These drawings organised and assembled the representation of the Emerald City. Examples included the Emerald City plan and a vertical ladder – the space of the storyteller.

The space of the storyteller

L. Frank Baum created the Emerald City as a story, a tale from his own experiences. Mapping these experiences connects the Emerald City to space and time. Experiences are bound to traditions, a socially constructed

spatial system joined to Baum's own time. For example: the Cowardly Lion was inspired by Baum's interest in Theosophy; Baum's own heart illness and the Tin Woodman's wish for a heart; the Scarecrow associated with the prairie farms in South Dakota where Baum lived and the Impressionist Movement influencing Baum's use of colour in both text and description. This drawing constructs a space and time of experience. A spatial web, a vertical webbed ladder that connects the Emerald City to cultural spaces, generations in time and fragments.

The Emerald City Plan

The unfolding of a book is a form of space-time compression. *The Wonderful Wizard of Oz* with its own geometries unfolds and produces a map. This is not a pre-given map of a city, but a mode of access to the Emerald City. Baums' writing style, his text is a process of scattering thoughts or actions with the reader. Mapping the text produces a city plan and puts the reader in motion. The plan provides a gateway moving through reality, virtual viewpoints and the mental spaces of imagination.

BENJAMIN WEB
LADDER

The Viewer and Engagement, ideas and impact.

Alexandra Drawbridge.

Art and Philosophy meet were the viewer is confronted with ideas that are outside their normal experience, it is art's ability to make this confrontation pleasurable rather than perplexing that gives the visual arts a special place in contemporary culture.

> *You can't introduce concepts, you can't produce*
> *argumentation. This type of media isn't the place for that,*
> *but you can produce a feeling of disturbance, in the hope that*
> *this disturbance will be followed by reflection.*
> *(Lyotard.1989: p181-182)*

An obvious way to cause this 'disturbance' is by blatantly shocking the viewer; however, I don't believe that it is always easy to engage with overtly difficult imagery. Reflection, instead, happens over time, and imagery that is somehow alluring, yet at the same time unsettling, might captivate the viewer, allowing engagement on a more profound level.

Perhaps an impact can be achieved through the 'negative pleasure'

(Kant. 1790: p91) of the Kantian sublime, described as: 'a rapidly alter-
nating repulsion and attraction produced by one and the same object'
(Kant. 1790: p107). The question is always that of the viewer's response,
and thus an understanding of communication.

In 'Hula Hoop Ad ITV' I have attempted to create an image that is erotic,
yet sickening. The original still, taken from a television commercial, has
been cropped to focus on the facial features, whilst removing the sub-
ject's individuality. Consequently the gesture becomes more potent, but
increasingly artificial; the resulting image might be more provocative, but
at the same moment shallow and pointless.

I have attempted to take this emotional 'desolation' further by giving
the image 'magnitude' (Kant. 1790 p92). The subject's face is immense
in size and scale, but with the reduction in detail it remains remote and
intangible in the same instant.

In Hula hoop ad the woman's gesture is an essential component in the overall impact of the work, but perhaps it is possible to take this process of reduction further and use more minimal imagery in pursuit of the sublime.

Beidler suggests that 'though minimalist artists emphasize the object itself rather than the emotions felt by the viewer, the result of this objectified art is simply a different sort of emotion and far from charming one' (1995: p178).

In the film 'The Unteachables Channel 4' I have attempted to create captivating, yet curiously terrifying imagery through minimal form. There is a sense of real film footage, yet the minimal qualities imply rather then give certainty. Without enough visual information to complete the representation, an indefinite shadow of the original broadcast footage emerges; the viewer is unsettled and displaced by this lack of detail. The minimalist piece is manipulative 'because it uses the sublime, the common ground shared by seduction and intimidation, to keep the viewer in place over time' (Beidler. 1995: p181).

Bibliography

Beidler, P. (Spring 1995), *The Postmodern Sublime: Kant and Tony Smith's Anecdote of the Cube*. The journal of Aesthetics and Art Criticism.

Kant, Immanuel. (1790), Translated by Meredith, JC. (1952), T*he Critique of Judgement,* New York: Oxford University Press

Lyotard, J. (1989), Edited by Lisa Appignanesi. *Post Modernism ICA Documents,* Free Association books.

Art and Philosophy
Artist Statement
Renée Mussai

The world is evolving into a state of Creoleness."
Bernabé, Chamoiseau, Confiant (1989)

Research led and informed through critical theory, my practice is rooted around notions of cultural hybridity and those complex new configurations of identity trans-cultural exchanges inspire. Driven by the desire to mobilize photography's potential as a powerful tool to playfully deconstruct historical iconographies, and to challenge outmoded notions of centre/periphery, inside/outside, self/otherness, objectification and subjectivity, my work combines critical theory and practice.

An ongoing body of work investigating the aesthetics of commodified *'otherness'*, **one drop rules** developed out of a fascination with the contemporary refusal to abide antiquated representations of difference in certain visual and verbal cultures of Europe,both linguistically and in their visual repertoire It presents a larger-than-life tribute to my son Maliq, the protagonist in a simple narrative of cultural heritage, belonging and the

proliferation of stereotypes, performing in the highly charged contemporary matrix of 'raced' representation - where blackness is delicious and consumable, and where questions of the oppositional gaze meet not yet internalised rules of confrontational looking. Touching on themes of inferential racism, politics of (in)visibility and aestheticised dichotomies of *self* and *other*, the piece explores the historic dilemma of myth, of superimposing one generic identity upon diverse nations and individuals, and the creation of a limited reservoir of essentialist visions.

Within this kafkaesque vacuum of cultural identity, where authenticity and purity are often lost in translation, and the personal fuses with wider philosophical questions around socio-political rhetorics in the complex image circuit of contemporary culture, my work aims to explore creative ways to visualise the idea of difference – alternating between the specific and the elliptical, negotiating afro – and euro-centric modalities; and how to create refreshingly impure, seductive yet non-didactic art, which raises more questions than it answers...

What philosophical question does your art try to answer?

Pedro Meades

The art and design world is worth millions. Pieces of work are being sold for astronomical amounts and the price of design continues to escalate. With such vast amounts of money floating about it must surely be tempting for artists and designers to ignore any moral convictions they may have and take on work that they would otherwise have rejected.

As a design student I wonder whether I would ever ignore my better judgement and take on a job based only on the money. Also I wonder whether any other designers have any sort of a moral struggle when it comes to their work. Whether they actually think about what they are doing and the implications of their work, who they work for and what they subject the population to.

I believe that art and design both have the ability to affect and influence people's lives sometimes even change their lives. Therefore, considering the power that is gained from having such influence there also must be some sort of responsibility regarding how they use their influence and a

responsibility regarding what they use it for.

So is it right for artists and designers to use this power of influence to make money for themselves? Is it right for them to use it to make for big brands and corporations and for them to use the power to make people buy things? Should artists and designers care if they are affecting people in any way, if they are creating consumer 'magic' to enhance con- sumption. Should an artist or designer have responsibility for what they produce and what connotations it might have?

I know of some designers that do consider such questions. Designers such as Ken Garland (who wrote the first things first manifesto), or Jonathan Barnbrook who is an outspoken critic of big business and advertising. But these seem few in this day and age. Even Barbara Kruger,who's bold work loudly protested at consumerism among other things, has now done all the January sale promotions for Selfridges.

I believe that every artist and designer should consider questions of re- sponsibility before they take on work. They should consider why they are producing such work, is the aim worthwhile and consider how it will affect people that are subjected to it. These are the sorts of questions I consider and attempt to answer in the work that I do. It was once ethics.

Perception and Reality

Natasha Bird

For centuries, one of the key philosophical questions has been; how does our perception affect our reality? What is reality? Does it exist outside of our perception?

John Locke stated that many of an object's qualities are one's body's reaction to the stimulus and therefore not present in the actual object – we create these qualities. George Berkeley argued that if this was the case the mind could effectively create the external world. As he put simply: 'To be is to be perceived'.

How can we know that the external world is as we perceive it, if all perception is through the limited tools of our senses? For artists this question has always been of great importance. Blake created a world that was entirely a mythological product of his own inner world, it was the perceived reality he called up from the depths of his conscious and unconscious mind, in this he was probably one of the most original artists of all time. Reality for artists is a possibility as well as a probability.

Inside the picture plane the artist alludes to another reality. With every stage of the photography process we remove the subject further from its original context. Just as we can question what lies beyond the selected borders of a photograph, we can question what lies outside the limits of our senses.

In Screen (2005) one questions what is beyond the screen, but through photography, this 'reality' has been erased. Nothing exists beyond the screen. Nothing exists outside of the photograph. 'Reality' exists only as pinprick floating in space. The title refers not only to the physical screen, but also to the medium of photography, the glass lens, our eyes and our bodies.

'... the function of the brain and nervous system and sense organs is in the main eliminative...leaving only that very small and special selection which is likely to be practically useful.' - Dr C. D. Broad

Baurdillard refers to the hyper-real but perhaps that merely portrays a nostalgia for the real that exists before the possibility of langauge.

Language text, and advertising
Patrick Roberts

Language results in similarities and the possibilities of agreement, and also indifference and disagreement. Language is also what distinguishes us from the apes. It is interesting to note that we call those individuals or groups who are savage or \ brutal, barbaric, which, etymologically, comes from the Greek barbarikós (those who go bar-bar-bar, related to the Sanskrit barbaras (stammering). In ancient Greek bárbaros meant 'those whose speech is unintelligible because they speak bar bar, that is, they do not speak Greek' – in a word, they are outsiders. We say that the meaning that one gives to a statement 'depends on where one is coming from', which is like the light bulb stories:

>*Q How many psychotherapists are needed to change a light bulb?*
>*A Only one, but the light bulb must want to change.*

In common usage 'to change a light bulb' means to replace it, but in a psychotherapeutic speech 'change' means emotional growth and development.

鳥

山花
山岩龍木
山吉
松保
以家名
文の家も
蔵丸

小岩
光掛
久保
人立本

さき柿じ澤嶋

君
たちばなぐり
端二千代
濱花家
由美子
竹昌田子
栄木

And for designers?
> *Q How many designers are needed to change a light bulb?*
> *A does it need to be a light bulb?*

The two sentences imply very different approaches: the first is a question anticipating a joke (there is a tradition about light bulb jokes), while the second comes from the design tradition, where the designer questions the framing of the brief - hence we laugh when we are confronted with the two possible readings. (amongst many)

So meaning it is not just about the actual words in a language, because of polysemy - the characteristic of words to have several meanings – but also because of the way language is used within a context of meanings. We differentiate between sets of meanings by calling them 'discourses'. When we wonder if we are speaking the same language we are actually wondering whether we share a discourse (the architecture), not just the lexicon (the bricks). Discourse is speech or writing seen from the point of view of the beliefs, values and categories which it embodies, and these beliefs constitute a way of looking at the world, an organization or representation of experience – an 'ideology' in the neutral non-pejorative sense. Different modes of discourse encode different representations of experience. Discourse is the body of utterances, which give meaning or frame what is being spoken about. Advertising is such a discourse.

If, for instance, my chair were now to collapse, the meaning I would give to the event would be affected by the discourse I use to describe it. (Context produces meaning) The discourse I use will point to my beliefs and values, and those of my environment. If I were to speak from a discourse that is not meaningful within my context, my statement would not make sense, such as: the chair broke because today is Saturday. However, our discourse is not a conscious choice. We do not just speak through language but are also spoken by language. Some people talk about a discursive practice. A discursive practice is a body of beliefs enshrined in a discourse we use, eg Marxism, psychotherapy, design, science are all discursive practices. That is, their discourse determines and limits what can be constructed and thought. Because our reactions are in concordance with out context, they appear natural, but that is also quite a problematic term.

The tool box we have sets up the response that we will offer to the same problem, and it will seem natural to us, as it happens with culturally determined responses. Culture, however is not only about country of origin but about any culture, e.g., the culture of designers, where it seems natural to us to question the brief. This is not dependant on the words we have, because with knowledge of the same words we can devise very different constructs. We could refer to discourse as the set of unspoken

rules that organize ones thinking about a subject. So I can consider the same event from different discourse, as in the example of the chair, and become aware that the speech or text I am confronted with comes from a particular perspective, such an environmentalist discourse, a political discourse, a feminist discourse. So a discourse, although it appears so, is not a reference to reality but to a reality. For instance, we may frame natural disasters and refer to them within an environmentalist discourse and we will argue for joining Friends of the Earth, or campaigning against the widespread use of 4x4 motorcars. Quite differently than if we address it from a humanitarian discourse and we will find ourselves proposing that action will be geared towards relief efforts. This is how we can identify when a politician uses a rightwing or left wing discourse – there are key terms in a particular connection in either speech, which will signal their position. Or, childbirth, which has been long conceived within a medical-ized view of women's health, as an illness requiring 'confinement' (the same word used to indicate the institutionalization of the insane) in hospitals, while the natural discourse has sought to integrate childbirth to the home and the family.

Accent and dialect also play a part as active indicators of the context defining the speaker.

When I hear an utterance such as
 I never done nothing (instead of 'I have not done anything wrong')
 I immediately assume that the expression identifies the speaker's cotext.

Or, conversely
 absolutely, old chap!

Yet, class, age, and culture of origin are very ubiquitous. We will find that some of us (most of us?) share a particular (design) discourse in spite of wide differences in geographical culture, mother tongue, schooling, etc. So, discourse is an internal context, constructed by conscious beliefs and unconscious prejudices, and from which I speak and which shapes my thinking. And we have to remember again the concept of barbaric, that is, those who do not share my codes. Becoming aware of the discourse(s) being used, will allow us to consider the way we may be forced to think by the discourse(s), which are, in turn, using us.

The Philosophical importance of collaboration

Jem Mackay

In 1637, Rene Descartes in Discourse on Method stated "I think therefore I am". This rational fundamentalism became the bedrock of individualistic thought and the philosophical driver of modern society. In response to Descartes statement, however, Friedrich Nietzche wrote in his book Beyond Good and Evil:

> A thought comes when "it" wants to and not when "I" want it, so
> that it's a falsification of the fact to say that the subject "I" is the
> condition of the predicate "think." It thinks: but that this "it" is
> precisely that old, celebrated "I" is, to put it mildly, only an
> assumption, an assertion, in no way an "immediate certainty."

Although we may be aware of the activity of thinking, this may not prove our own existence. Nietzche suggests that a more appropriate phrase would be along the lines of "It thinks". Perhaps, we could say, then, that a basic element of philosophy is that thoughts occur?

This is an important idea when it comes the field of collaborative art. The act of thinking takes place, but can we ever be sure any particular individual has generated it? Can any individual ever claim that they alone are responsible for an idea, if a thought happens outside of personal control?

In The Third Hand, Charles Green looks at collaboration in art from Conceptualism to Postmodernism. He says that collaboration is a symptom of our times and he also looks at three different types of collaboration:

"First, between 1966 and 1975, the future members of Art & Language constructed highly bureaucratic identities. Second, at the end of the 1960s, Boyle family, the Poiries, and the Harrisons seperately developed close-knit collaborations based on marriage or lifetime, family partnerships. Finally, artist couples developed a third authorial identity effacing the individual artists themselves" [The Third Hand p.x]

Green argues that collaboration in Art has been happening as an evolutionary process that culminates in a 'Third Hand' i.e. an identity outside of the individuals involved.

A similar line of thinking can be seen from Kurt Koffka in Principles of Gestalt Psychology, where he talks about Gestalt Theory

"It has been said: The whole is more than the sum of its parts. It is more correct to say that the whole is something else than the sum of its parts, because summing up is a meaningless procedure, whereas the whole-part relationship is meaningful." (Principles of Gestalt Psychology. New York: Harcourt-Brace. p 176)

Something happens when groups of people work together and this creates an identity outside of the individuals involved. At a football match, for example, individual fans can be intoxicated by the sense of group spirit. It can be as if there is a character, outside of the any single individual in the stands, that encourages, motivates and excites the people there.

In a presentation called "The Creative Act" in Houston Texas, April 1957, Marcel Duchamp stated:

"All in all, the creative act is not performed by the artist alone; the spectator brings the work in contact with the external world by deciphering and interpreting its inner qualification and thus adds his contribution to the creative act."

Duchamp's argument is that the creative act, by necessity, has to have more than one person involved. A solitary individual cannot produce art until someone else is able to perceive it. Both the artist and the perceiver of the art create an interdependent relationship, through which art is produced. Yet in Art, traditionally, we can see much more responsibility has been placed at the feet the artist, rather than those of the perceivers.

In the fifties, John Cage played around with this idea at Black Mountain College in the United States. Cage collaborated with Robert Rauschenberg and dancer Merce Cunningham in 1952 and organised what was considered to be the first "happening". The "happening" known as the Black Mountain Piece was an event where there was no centre of attention. The audience sat in the middle of the room, whilst artists performed around them. In this way, the audience was able to pay attention to whatever they found interesting. They took the responsibility of choosing where they would look and so there is much more of a balance of responsibility taking place, here.

John Cage also first performed 4'33" in 1952 at Black Mountain. A pianist sat at a piano and did not play a single note for four minutes and 33 seconds. During this time, the audience were left to meditate on the incidental sounds of the world around them - people shifting on their chairs, someone coughing, a plane passing overhead etc. The work was an open invitation in which the audience could participate. The question of who authors this particular kind of work comes to the fore. As the creator of this piece, Cage has certainly handed over his role as author to other people there. Yet no individual can claim responsibility for what happens during the 4 and half minutes of the performance, because it is comprised of the totality of sounds that everyone on the stage and in the audience makes together.

Both Marcel Duchamp and John Cage were highly influential to the art movement, Fluxus. In the 1960's and 1970's, Fluxus was noted for the blending of different artistic disciplines, primarily visual art but also music and literature. It was loosely organised by George Maciunas and amongst its members were Joseph Beuys, George Brecht, Nam June Paik and Yoko Ono. Fluxus was a very social movement and Fluxus artists often either created their own work with whatever materials were to hand or collaborated in the creation process with their colleagues. Similar in spirit to the earlier art movement of Dada, Fluxus emphasized the connections between everyday objects and art and deliberately integrated the audience members into their performances in order to create random interventions, thus realizing Duchamp's notion of the viewer completing an art work.

In literature, Umberto Eco also looks at the advantages that come from ambiguity within literature in "The Open Work". He advocates fields of meaning rather than strings of meaning, and feels that if a writer tries to specify exactly what is understood by the reader, it is very unfulfilling for the reader.

Yet again we have a tendency to allow the 'perceivers' to take much more responsibility in the creative act.

In the creation of computer software, there is a similar philosophy of the importance of collaborative thinking taking place.

Computer programming in general is done by groups of people and there are two schools of thought about it. One holds that computer code is a product that can be owned by the author(s) who wrote it. This is called proprietary software, and is exemplified by the software produced by Bill Gates' company, Microsoft. The other advocates that for the sake of overall progress, people should not try and keep hold of coding methods and techniques that they have discovered for themselves. Software should be open and freely available to whoever wants to use it or look into it. This is the rationale behind open source software. This method of producing software, however, is by no means inferior, and this can be exemplified by Apache Web Server software, which has nearly 70% of the global market share of web servers.

With proprietary software, a substantial amount of resources are tied up in trying to stop other people from accessing the code, understanding it, changing it and writing additional code for it. In open source software, however, people are actively encouraged to access even the most vulnerable areas of the code, to write additional code for it, and participate in how the software can be adapted to specific real-world situations. The advantage being that the more people can inspect the code, the more reconstruction can take place on areas of code that are not so well written. As Eric Raymond (1999, p1) puts it: 'Given enough eyeballs, all bugs are shallow'.

French theorist Nicolas Bourriaud argues in his book Relational Aesthetics, that art can be judged on the basis of the inter-human relations that they represent and that artistic practice can take as its point of departure the whole of human relations and social context, rather than independent and private space. The development of Relational Art, Bourriaud considers, stems essentially from the birth of a global urban culture. He argues that it is born out of the observation of the present and the sphere of human relations itself is the site for the artwork. He included different forms of social interaction as art from the 1990's at the Walter and McBean Galleries of the San Fransisco Art Institute. A typical example would be someone like Rikrit Tiravanija, who prepared and shared a meal with thirty people.

Fifty years ago, an obscure jesuit priest by the name of Pierre Teilhard de Chardin set down the philosophical framework for a planetary net-based consciousness. He believed that a vast thinking membrane would ultimately coalesce into "the living unity of a single tissue" containing our collective thoughts and experiences. Today, we have just such a membrane - a vast intertwined world of telephone lines, wireless satellite-based transmissions, and dedicated computer circuits. It is the Internet.

Perhaps, it wont be too long before the Internet itself, in a moment of selfawareness, states that because "it thinks, it is".

Contributors

Alexandra Drawbridge completed an MA Digital Arts at Camberwell College of Arts in 2007. Her work captures familiar imagery from transient moments of broadcasting, and reconfigures this into something more tangible. This creates a work of art that allows time for reflection, being interpreted in a way that would not have been possible in its original form

Emmet O'Farrell is a recent MA graduate in Digital Arts from Camberwell University of the Arts. With a background in Video Production and Direction he has worked in both the UK and U.S. Also an Illustrator, he currently lives in London.

Bess Frimodig is pursuing a Ph.D. at The Centre for Fine Print Research at UWE in Bristol in 'An honourable practice: Printmaking and Social engagement. Her previous education was completed in Sweden and Japan. She holds a BA from University of Kansas MA from School of Visual Arts in New York and a MA from London College of Communication. She divides

her time between teaching at London College of Communication and London Metropolitan University in London and her studio in Whitechapel. She exhibits continuously around the world as a printmaker.

Kathy Kubicki is a Senior Lecturer in Photography, University of the Creative Arts - had a long overview article of film, video and installation art at The Venice Beinnale 2005 published in 'Art In Sight, Filmwaves 28' as well as a review of work of USA artist Jordon Baseman and his show at Matt's Gallery London in the same journal. Her Audio Arts interview with French artist Daniel Buren (published CD and introduction) is also to be published in a forthcoming book of the best Audio Arts interviews by Phaidon 2007.

Jane Madsen is a film and video maker whose work includes experimental films, installation and documentary; she has a background in art history and cinema studies. She has written and published articles on film and art. She currently teaches at Camberwell School of Arts and has recently started a PhD at the Bartlett with practice at the Slade.

Richard Osborne is a writer and philosopher who teaches at Camberwell College of Art. His works include Philosophy for Beginners, Art Theory for Beginners, Megawords (cultural dictionary), The Universe, and Freud for Beginners, AES Last Riot 2 . Introducing Eastern Philosophy, etc.

Patrick Roberts Clients: Wagamama, BBH, Adidas, HSBC, Conran Design Group, UNICEF Awards: 2 Design and Art Directors (D&AD)
Exhibitions: Letterpress' 2006, Design Museum MOMA , British Library
Academic: Director of Graphic Design studies, Camberwell College of Art, London Associate director of Informations Enviroments Research unit University of the Arts, London

Nina Rodin is a graduate of Painting, Camberwell College of Art London and currently studying at the Slade. http://www.ninarodin.com

Zoe Tillotson recently completed her Ph.d at the University o the Arts, London and is now an Educational Consultant with a London Authority. She has done work centred on ephemeral art with the Department of Anthropology, Cambridge University, with the Horniman Museum and at Fenton House, National Trust.

Marty St.James is a practicing fine artist with an international and national standing. He has artworks in major public and private collections. Originally a performance artist recent highlights have been one person shows at the Chelsea Art Museum, New York (January 2005) which formed the basis of a conference...Somewhere or inbetween and at the Contemporary Art Museum in Moscow, Russia (2003).

Marty St.James is Principal Lecturer and Head of Fine art at the University of Hertfordshire UK and is a research supervisor and examiner. A Wingate Scholar, Paul Hamlyn award winner, Gulbenkian and AHRB recipient with awards from the British Council and Arts Council St.James has traveled and exhibited extensively worldwide.

His talks at the National Gallery and Courtauld Institute are well known (onBill Violas' works 2003). He has represented Britain abroad in exhibitions via the British Council and others including Electronically Yours at the Metropolitan Museum of Photography in Tokyo (1998). During 2000 his yearlong digital interactive work at the Scottish National Galleries, Edinburgh, ' Picture yourself' celebrated the millennium with the public able to view themselves on display. During 1998 St.James showed video works at the Ferens Art Gallery and Museum including the miniature piece Poppy (after John Hoppner's painting of Anna Milbank) which is in the collection. He also represented the year 2000 in the National Portrait Gallery's millennium exhibition , Painting The Century, 101 Portrait Masterpieces from the 20th Century with Boy / Girl video diptych showing with Picasso, Freud, Bacon, Munch, Warhol, etc.

Andy Stiff is the Director of the MA Digital Arts, University of the Arts, London. After eight years working with the co-operative arts groupD-Fuse, focussing on web, video and dvd technology to produce installations and live a events, Andrew Stiff was appointed to run the MA Digital Arts and MA Digital Arts Online courses at Camberwell College of Arts. He now works as an independent digital artist, using his experience of working within the Architectural environment to explore the multiplicities of perception in our built environment. He has shown video installations in Rome, Seoul and recently as part of the London Architecture Biennale.

Renée Mussai studied for a degree in Art History at the University of Vienna, Austria and holds an MA in Photography from the University of the Arts London. Associated with London-based photographic arts agency Autograph ABP since 2001, she currently manages the establishment of their Archive and Research Centre for Culturally Diverse Photography at Rivington Place. She was the recipient of a Sofie- and Emanuel Fohn fellowship in 2000 and 2006/07.

Halime Ozdemir, born in Famagusta, Cyprus commenced her career at UAL specialising in Drawing, combining additional skills in Printmaking and Photography. Built her appreciation of Philosophy which she had been exposed to at The Camberwell College of the Arts.

Having developed a sound grounding in the arts, she has been a practitioner and exhibited in The Menier Gallery (Central London) and participated in the annual Camberwell Arts Festival 2005 (and been invited to

2008). She has also worked on European projects such as CORPSET Project group. Has been invited to be artist in residence in Malaga, and work on projects based in Istanbul. As founder of The Kardelen Project UK she will be project manager for an independent internationally released film production in 2009.

Jenny Wiener BA (Hons) Drawing - Camberwell College of Art (2003-06); MA Fine Art - Printmaking - Royal College of Art (2006-08). Selected group exhibitions include: Landslide, Cafe Gallery London (2008), Mapping, Bury Art Gallery Museum & Archives (2007), Rummage, The Gallery, Stoke Newington, (2007), Over and Over Again, Sadler's Wells, London (2007); Art The Musical, Stroud House Gallery (2006), Jerwood Drawing Prize, Exhibition Tour (2005-6) www.forensicfairytales.com

Sophie Reed studied BA Drawing in Camberwell College of Arts graduating in 2007. She is interested in Philosophy and Architecture .

Joon gi Yoon is an artist working in London who has exhibited here and in Korea, he is currently studying for an M.Phil at the University of the Arts and works for Anthony Gormley.

Anastasia Sichkarenko is a photographer and designer who lives and works in London, she has graduated from Camberwell College of Arts in 2007 and currently she is doing a MA Communication Design course in Central St. Martins.

Pedro Meades is a graphic designer who recently graduated from the University of the Arts. Camberwell.

Also from Zidane Press:

Graphic Design: This Way
by Peter Anderson , Patrick Roberts
A Radical introduction to a complex contemporary topic by two leading practitioners.

£9.99.

Darwin's Nuts
by Jim Alexander

A scintillating introduction to Darwinian theory.

£8.99

Art Theory for Beginners
by Richard Osborne and Dan Sturgis

The complete Introduction to the history of Art Theory.

£8.99

JIM'S VERY LARGE HANDBOOK OF ROCK 'N' ROLL

Jim Alexander.

Everything you need to know about rock n roll.

£4.99.

Philosophy in Art.

Edited Richard Osborne.

Introduces contemporary debates in philosophy and art.

£9.99.

To Order.

www. Zidanepress.com.

Or zidanepress@gmail.com

graphic this way
design

how to make the world
intelligible with Graphic Design

Peter Anderson
Patrick Roberts

graphic design this way